Gecko Keck

DRAW
SCI FI

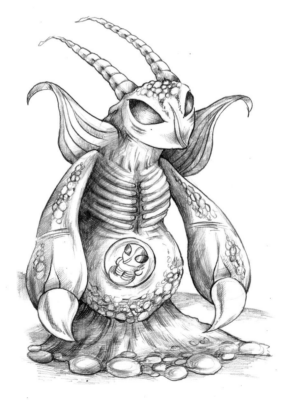

CONTENTS

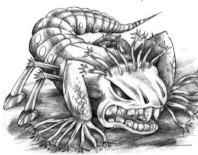

The term 'Science Fiction', in combining two words, indicates that both science and art are involved in this genre. In the world of Science Fiction authors and illustrators portray things that are at present not scientifically or technically feasible – although they might become reality one day in the remote future or in some other world.

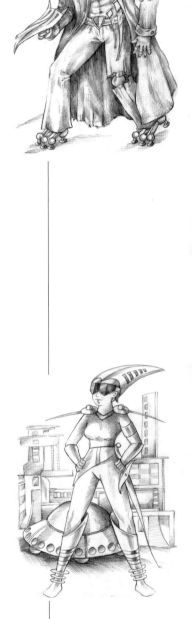

What is interesting is that scientists often attempt to use technology to realise the visions of the future dreamt up by illustrators. Unfortunately such ideas of the future are often very dismal and menacing, particularly in Science Fiction films, and here we also have a feeling that such visions could very well come true.

Although the fields of Science Fiction and Fantasy are related, there are several key differences between them. While Science Fiction is always based on science and technology, Fantasy revolves around the worlds of mysticism, myths and legends as well as traditional tales from different cultures. Fantasy often tends to have a historical feel to it or something of the Middle Ages, while Science Fiction normally looks into the future. These genres can of course also be combined, with the borders between the two becoming so blurred that they can hardly be defined. But that's what makes the whole thing so exciting!

In this book I want to familiarise you with forms, figures and images from the world of Science Fiction. Why not pick up paper and pencil while you're reading and join in? I hope you enjoy yourself!

G. Kleck

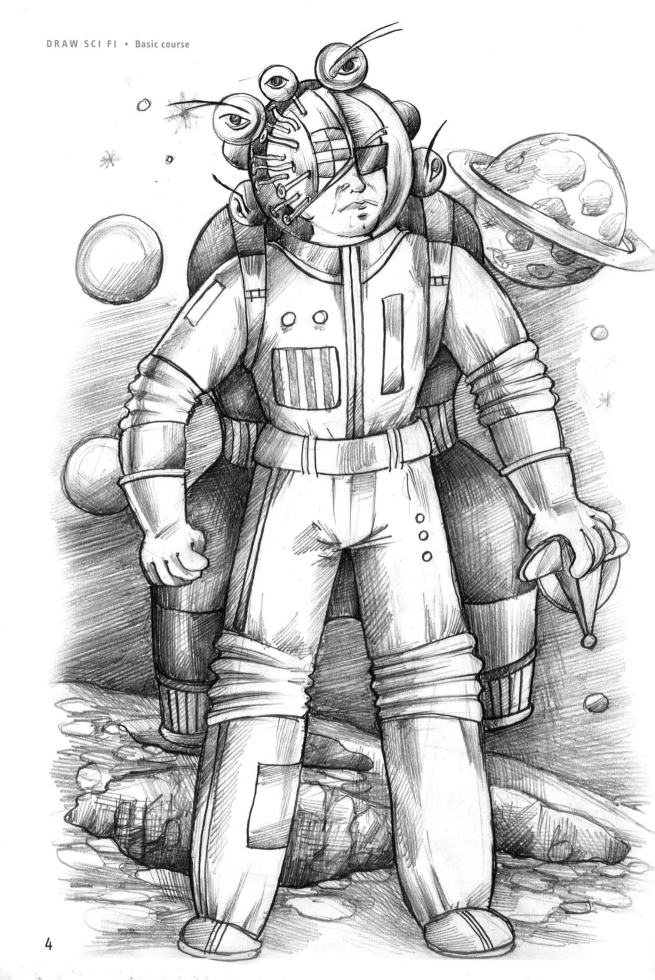

Anyone wanting to familiarise themselves with the drawing of Science Fiction for the first time should also take a look at the great classical films of this genre while working through this book, to gain a better understanding of the field – for example, George Lucas's 'Star Wars' trilogy, the 'Alien' films or the 'Matrix' trilogy. Science Fiction novels are another great source of inspiration. The advantage of books over cinema is that you can make use of your own fantasies here, imagining your own figures from the author's description.

Great models

Good examples of successful Science Fiction classics are the TV series 'Star Trek', the works of Jules Verne (1828–1905) and George Orwell's '1984', which is striking for its visionary view of our modern world.

LEARNING OBJECTIVES

Science Fiction is not an easy genre in which to learn how to draw. So do not expect too much from yourself at the start.

▶ This book will help you learn how to create your own Sci-Fi figures and ideas. It shows the individual steps in detail from the very first stroke of the pen to the finished picture, including many examples.

▶ The success of your motifs will largely depend on how good you are at shading. If you know how to do it, you will find it easier to make a figure, planet or object look three-dimensional.

▶ It is the play of light and shade that gives a motif its authenticity and feeling of life. If you train your eye to recognise light and dark, you will soon no longer be a beginner.

▶ Perspective determines whether something looks technically correct and plausible or wrong and askew. This is crucial for buildings and vehicles in the world of Science Fiction.

Drawing means 'working with lines', while in painting it is the surface that dictates the style. The use of lines involves graphic art. If you simply pick up any old pencil and start drawing, you will soon discover your limits. A stroke is only ever as good as the tool used to produce it, particularly when it comes to illustration.

MATERIALS

Do not start off with materials that are too complicated – for your first pictures just choose materials that allow you to explore the theme easily.

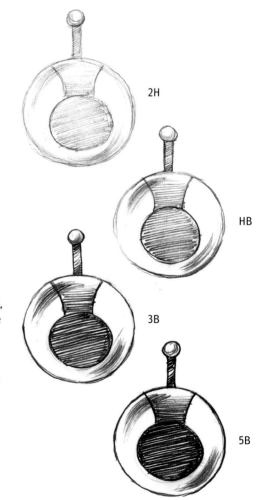

2H

HB

3B

5B

Pencils

A good selection of pencils and white paper are undoubtedly the most suitable work materials for a beginner.

Degrees of hardness

Pencils are available in various degrees of hardness, with 'H' standing for hard and 'B' being a soft pencil. This is broken down further using numbers such as 2H, 5H or 3B. The higher the number, the more marked the degree of hardness in question, i.e. 6B is very soft while 4H is extremely hard.

These pictures of a little space capsule show the effect of using different grades of pencil. The drawings illustrate the different hardness levels – the further down the page the drawing is, the softer the pencil used.

Coloured pencils

Alongside regular pencils, coloured pencils are also suitable for beginners. Although they are not so easy to erase, the technique required is in other respects little different to working with a regular pencil. The addition of colour only makes things slightly more difficult. But that is sometimes the attraction – actually drawing the planet Mars in bright red!

TIP

When it comes to drawing futuristic worlds, all shades of purple and blue are particularly suitable. Red, orange and yellow are also very effective if you want to draw new, dynamic civilisations or figures.

Drawing paper

Basically you can use anything, as long as you can draw lines on it. However, white paper or a sketchbook is most suitable for a beginner, particularly when a difficult genre such as Science Fiction is involved.

SHADING

Shading can be used to give a more three-dimensional look to various shapes by adding light and dark (i.e. areas of light and shade) to a drawing. Here you can see how this is done using a futuristic helmet, a simple geometric object, as an example. Shading involves three basic techniques.

Simple shading

The simplest version of shading uses lines running parallel to each other. To create the impression of a uniformly grey area, it is important to make sure that the fine lines are always spaced as evenly as possible. This takes some practice at the beginning.

Cross-hatching

Cross-hatching, as shown in the drawing in the middle, can be used if you want additional graduations of grey in a shaded area. Draw in fine parallel lines – these must be added over the first shading lines and be drawn at right angles to them. This will make that part of the drawing look darker.

Form lines

TIP
You can of course use all three techniques in a single drawing, depending on which one seems most suitable at each point.

The third technique uses so-called form lines. They are also drawn parallel to each other, but are not straight as in the first two examples. Instead, these lines follow the contours of the object to be drawn and can thus be curved or rounded, for example. This type of shading gives a strong three-dimensional look to a drawing.

SIMPLE FORMS

Working in steps

The practical section from page 22 onwards contains 14 motifs which can be used to practise on. They will help you make simple, basic forms more complex and interesting. When drawing, one of the most important skills is the ability to identify the essential structure and make use of it as the basis for a picture.

From the simple to the complex

It is only when you have identified the basic concept of an object or creature and outlined it that you can go on to develop the details and surface features. Three very simple examples can be found below. The drawings here show how you can start with a simple form and create a figure from the world of Science Fiction in three stages.

TIP

First of all try to simplify the motif you want to draw by reducing it to absolutely basic geometric forms.

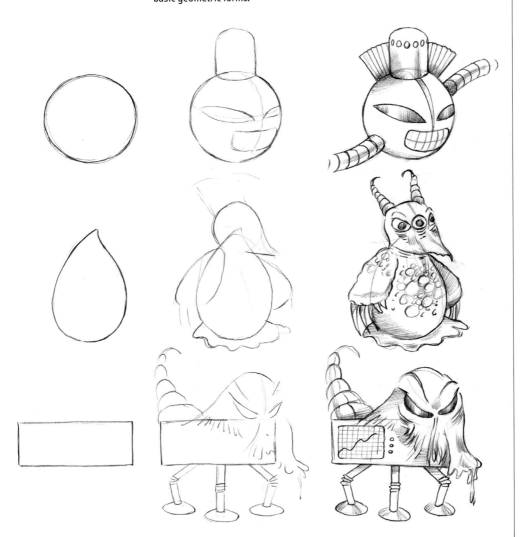

TIP

In his work, the painter Paul Cézanne's motto was 'see nature in terms of cone, sphere and cylinder' – and this applies to any illustrator.

PERSPECTIVE

Being able to draw with proper perspective is very important, especially when it comes to Science Fiction. Although this book deals mainly with Sci-Fi figures, you will sometimes want to draw a building, vehicle or spacecraft, if only somewhere in the background. Going into great detail here is beyond the scope of this book, which can only give you a basic idea of perspective. But the following examples illustrate what options are available.

TIP

The two drawings below demonstrating the use of perspective show two simple objects that resemble machines. Once you have more practice with perspective, you can really start to use your creativity here. In any event, it is worth getting hold of additional material on this subject.

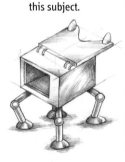

Isometric drawing

This means that all lines opposite to each other which run in the same direction, either in reality or in the imagination, are also drawn absolutely parallel in the picture.

One-point perspective

Receding lines all disappear at a single point on the horizon. Horizontal lines run parallel to the horizon and are at right angles to all vertical lines.

Two-point perspective

Receding lines disappear at two points on the horizon. Vertical lines are positioned at right angles to the horizon, as with one-point perspective.

Three-point perspective

Two disappearing points are located on the horizon, as with two-point perspective, but there is one disappearing point that is positioned well above or below the horizon. All lines disappear at one of these points.

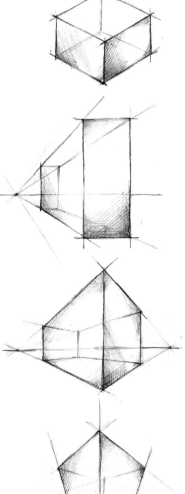

TIP

Do not use a ruler to practise perspective – this will not make you any better. It does not matter if your drawing is technically not 100 per cent correct.

LIGHT AND SHADE

Below are four very simple shapes from the world of Science Fiction. Shading has been used here to distinguish between light and shade. The arrows show which direction the light is coming from in each case. The darker a part of an object or figure is supposed to be, the closer you have to draw the lines in the shading.

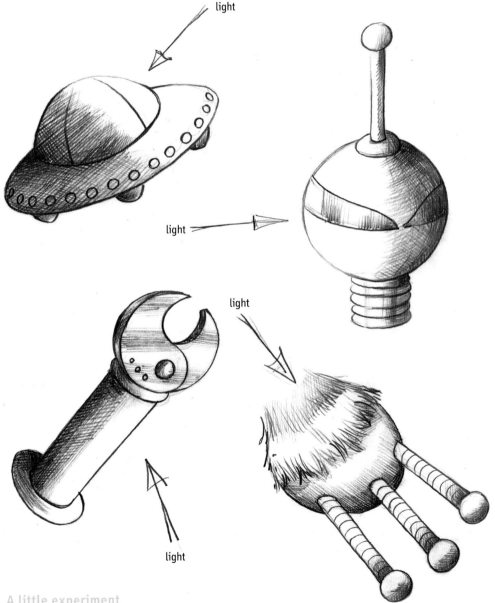

light

light

light

light

A little experiment

It may be helpful if you actually take a torch or table lamp and shine a light from different directions on a geometric object such as a ball or vase. When doing so, carefully observe the division between light and shade and try to reproduce this in your drawings.

TIP
A key objective for shading is to use light and shade properly and in keeping with what you want to do. Please take another look at page 8.

11

SURFACES

One of the key skills for an illustrator is to give a realistic appearance to natural and artificial surfaces. Structures and materials must look convincing, particularly in the world of Science Fiction: the cold, shiny metal of a robot, soft shaggy fur, a mop of hair or soft skin. Even drawing liquids is one of the basic skills required in this genre.

Structures and forms

The following drawings show several examples of how to draw different materials. The first three are of metal surfaces, while the picture in the middle on the left creates a clear impression of shaggy hair and horny claws. A transparent mask, a viscous mass and metal rods attached to a hand can be seen at the bottom.

TIP

Spend a lot of time practising the drawing of different materials and try to use the shading techniques shown in the illustrations.

TIP

The drawings elsewhere in this book show many other options. But also take a look around you for inspiration: ceramic or plastic surfaces have their own special character as well.

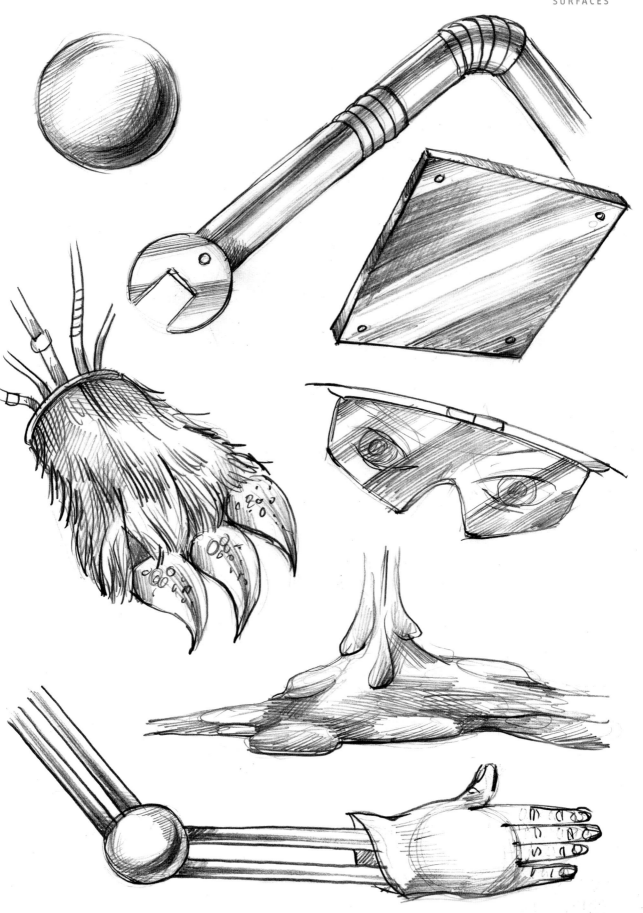

THE MOST COMMON MISTAKES

It is annoying, but mistakes can quickly creep into drawings. However, guarding against the most frequent failings is not as difficult as you might think. Basically there are six mistakes that crop up time and time again:

1 Using your eraser too often

2 Working with blunt pencils

3 Incorrectly positioning your motif on the page

4 Using pencils with the wrong degree of hardness

5 Incorrect perspective when drawing buildings, containers or objects

6 Smearing what you have drawn with your hand

1. Using the eraser properly

Only use your eraser when absolutely necessary. It does not matter if you can still see faint lines when you have finished, particularly lines from the basic outline. On the contrary, this will make your drawing look more professional.

TIP

If you have to keep rubbing out parts of a drawing, it is better to start it again.

2. Sharp points

Make sure you keep your pencils nice and sharp. Being lazy or trying to economise is quite wrong here, as working with a sharp point is far easier than working with a blunt one.

3. Good planning

Plan the position of your motif on the page just like an architect. Otherwise you may want to add another detail later on only to discover that you have run out of paper at the side or the top. See below for what happens if you have not positioned your drawing on the page properly from the outset. This is why you should first of all make a rough plan of the most important outlines before adding the detail.

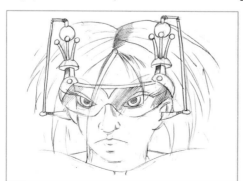 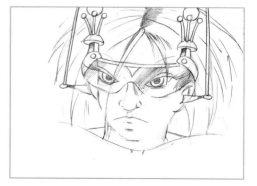

4. Choosing the right pencil

Grades of hardness between HB and 2B are generally most suitable, although this is sometimes a matter of taste.

TIP

It is obviously not very sensible to draw a figure in the foreground with a 2H (i.e. light-coloured) pencil and one in the background with a 4B (i.e. dark). It is better the other way round.

5. Choosing the right perspective

Perspective is not a simple matter. If you want to really improve here, you should try and work on this by getting hold of books dealing with perspective – and in particular, keep practising.

6. Keeping it nice and clean

Place a piece of white paper between the drawing and the ball of your hand. This will greatly help to stop you smearing your picture.

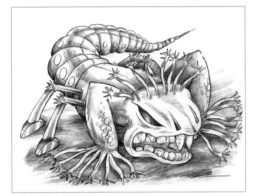 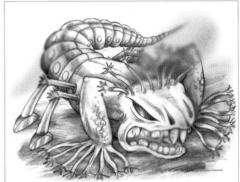

Individual development

You will most probably find that you always run into the same problems in your drawings. This is perfectly normal and part of the development process that is all too familiar to anyone who is being creative. We all have our strengths and weaknesses. If you want to make progress, it will help if you take an objective look at your finished picture and try to assess it. Pinpoint what you do not like about it. Is the perspective wrong or the way you have drawn the light? Is there something amiss with the basic outline or are you not happy about the facial expression? You are probably the only person to notice such points, but if they really bother you, then adopt a systematic approach to improving your work:

> ▷ Practise drawing perspective and adding light/shade to different objects. See pages 10 and 11 for further information.

> ▷ If there is something wrong with the basic structure of the motif, take greater care next time to get the outline right. Make several attempts at this if necessary.

> ▷ If you are not very good at drawing facial expressions or postures, on the other hand, look for examples in books on portraiture to practise on.

THROUGH THE GALAXY

The vast dimensions of the universe are beyond human comprehension, and we are therefore enormously fascinated by it. At the same time many people also feel threatened by it – especially when we consider how tiny the Earth and the creatures that live on it are in relation to the expanse beyond!

Creative energy

Try to channel the feelings you have when thinking about the universe into creative impulses. The illustration shows several simple pictures of planets, stars and meteorites. Practise drawing these motifs so that you can use them later on to fill in the background of your pictures. One of the absolutely basic skills of a good illustrator is being able to draw a simple circle properly. And what better practice here than with planets and other celestial bodies?

INFO
TERMINOLOGY

Celestial bodies are first and foremost stars, which also include our sun, as well as planets which travel round a star. The bodies which orbit planets are known as moons. Meteorites are particles which move about the universe freely, while comets often trace a complicated path.

Scientific basis

You should also take time to study the shape of the planets in our solar system: new breathtaking pictures can be found on the Internet or in scientific publications. In particular the gas giant Jupiter, or Saturn with its system of rings, make fascinating models.

TIP

Draw your own planets and galaxies and create beings that might live in these worlds.

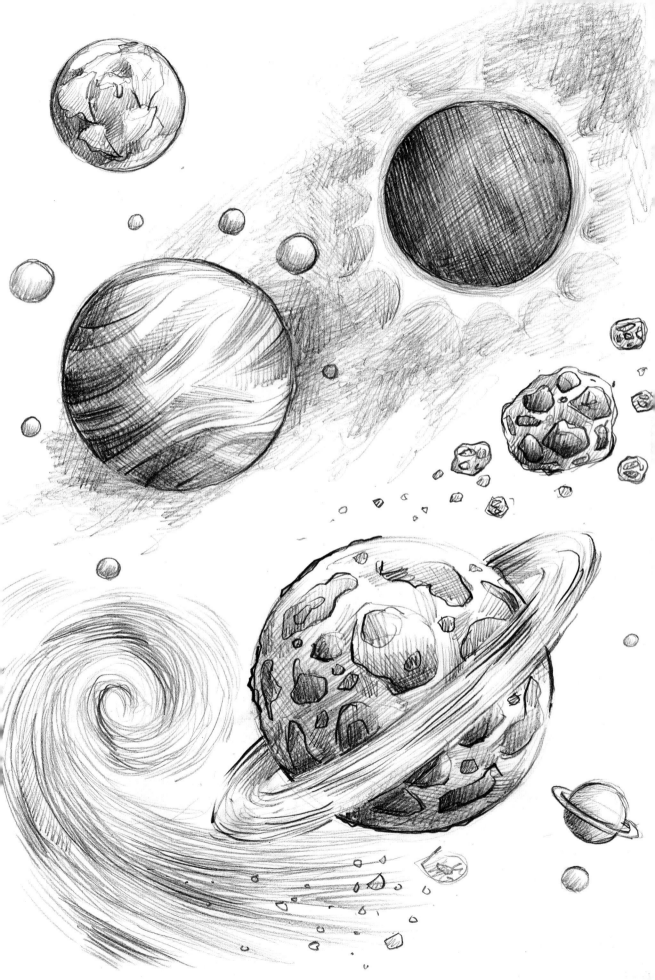

HOW TO FIND
A MOTIF

You are probably now itching to get down to work and try out a motif! With this book you can expect to get a good result relatively soon with a few basic skills.

INFO

TAKE IT EASY

It is best to use your intuition when selecting which motif to start with from the wide range of options given. To make sure it is not too difficult, you can take a look here to decide which figure or scene you think you can manage.

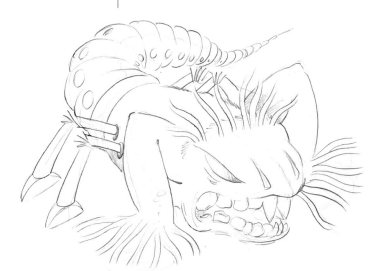

Tips to help you on your way

Proceed as follows:

- First select a motif that appeals to you.
- Try to outline the basic shape shown for it.
- If this drawing is successful, you have chosen a motif that not only suits you, but is also one for which you most probably have the right drawing skills.

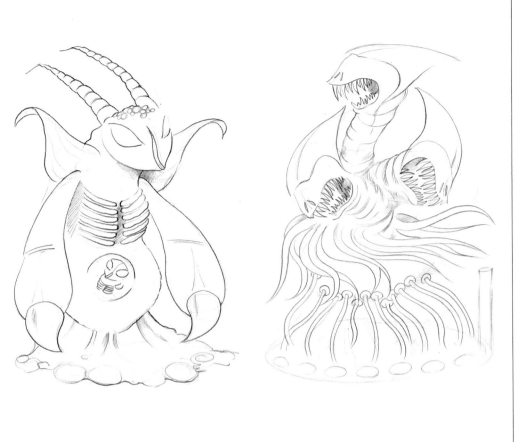

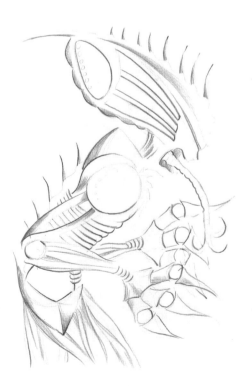

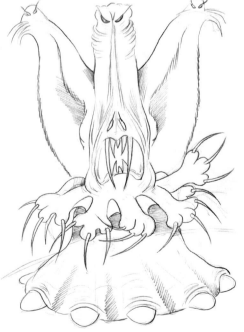

BASIC COURSE

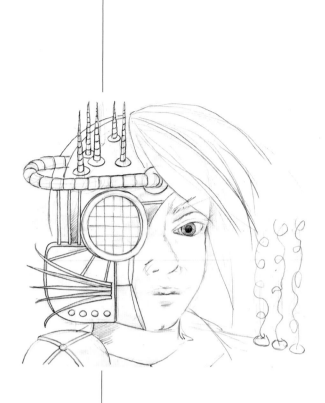

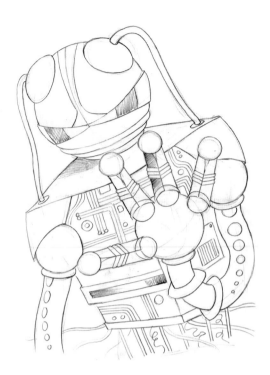

INFO

WHAT DO YOU WANT TO START WITH?

If you do not have much experience in drawing, it is a good idea to start with simple forms.

▸ Examples of figures that are easier to draw include the Alien Sentry, Indian Space Surfer or Timegate.

▸ More challenging figures include the Lizard Alien, Three-headed Alien or Future Woman.

▸ The Robot Landscape, Cyborg Alien or Robot Torso figures are only suitable if you are more advanced.

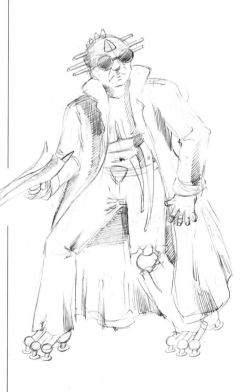

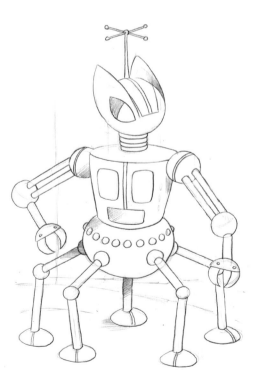

BASIC COURSE

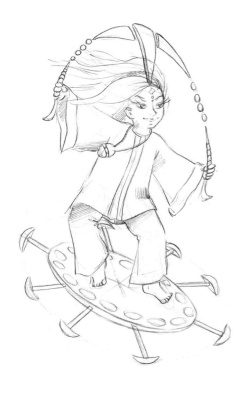

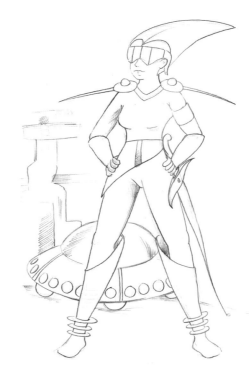

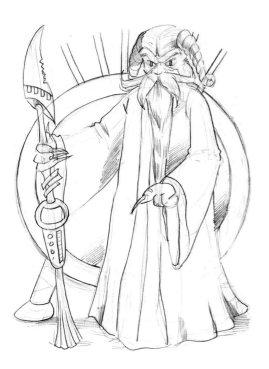

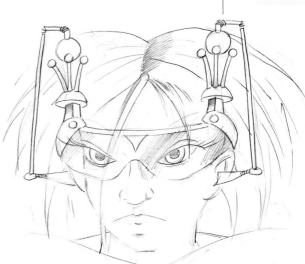

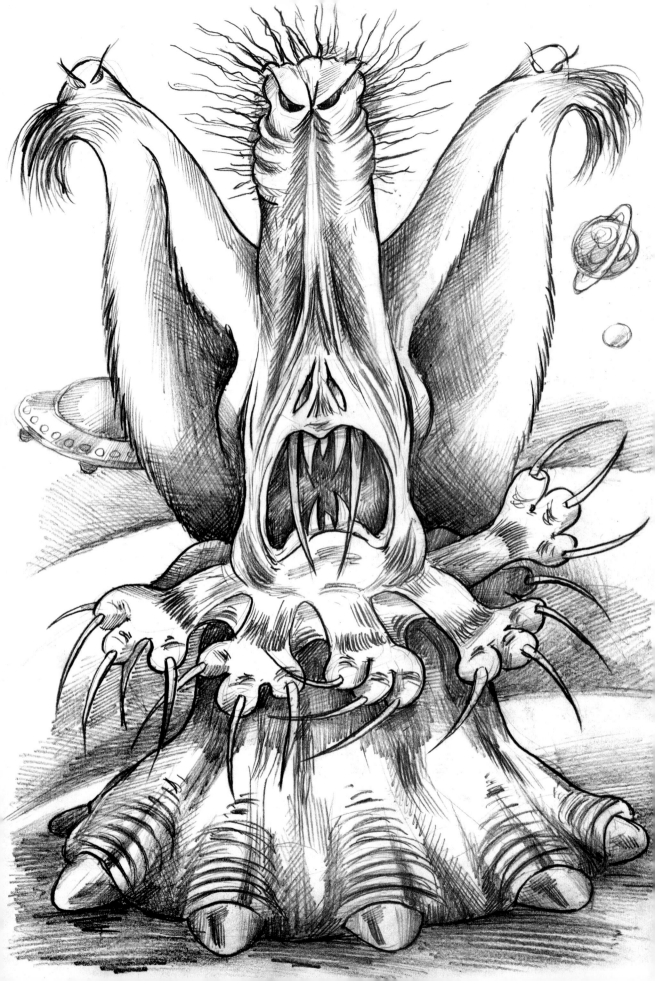

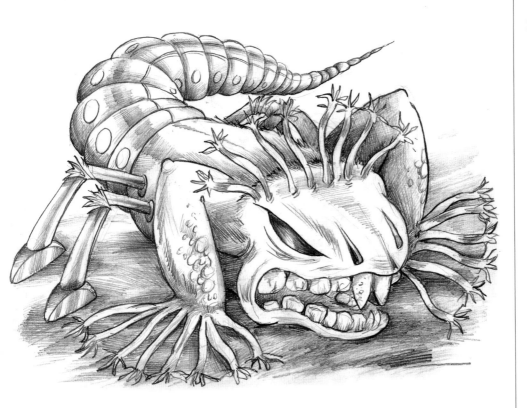

INFO
**LIFE FORMS
IN THE SOLAR
SYSTEM**
Interestingly, the
latest research into
Venus and Mars has
shown that there is
indeed (or used to be)
life on these planets.

ALIENS

The term 'alien' comes from the Latin (alienus = foreign, strange) and has now also come to be used simply for people who are foreign or stateless. In Science Fiction, on the other hand, this word refers solely to extraterrestrial life forms that do not live on Earth or come from it. There are all kinds, sizes and variations of aliens. They include tiny, simple beings like viruses and bacteria as well as highly intelligent and complex creatures. People already believed in the existence of 'little green men' before the Space Age and imagined in particular that they came from Mars.

EXTRATERRESTRIALS

The universe probably came into being some 15 billion years ago – a huge expanse without air that seems to stretch into infinity. Outer space is so vast, it is incomprehensible to man, and it is hard to believe that higher life forms do not exist on another planet.

Drawing aliens

No-one knows what there may actually be far beyond our solar system and the planets we have discovered: we cannot picture this in our boldest imaginings. This is why alien life forms have always presented a challenge to people with a creative bent. Such creatures, which are as striking as they are enchanting or repellent, range from the cute, such as E.T., to the ghoulish aliens that swallowed up everything in the 'Aliens' series. And the possibilities have not been exhausted by any means.

A touch of realism

Sometimes it is not very realistic when a film about aliens shows creatures that are intelligent enough to build spaceships and threaten the Earth but only have awkward limbs and clumsy 'hands' that would not even be able to switch on a light! Try and avoid such discrepancies where possible.

WORKSHOP TIPS

▶ Magical or delightful alien beings that inhabit far-flung planets often reflect the dream of a harmonious relationship between humans and extraterrestrials. But fantasies may also go off in an entirely different direction: grotesque, aggressive, cruel-looking creatures that inspire fear in the beholder. Such imaginings also belong to the world of Science Fiction.

▶ Start off by using existing models when drawing aliens. It is often a successful combination of details that will make a character 'work' – like the hairy Wookiee from Star Wars.

▶ The eyes play a key role here. Let yourself be inspired by the world of animals: outsize insect eyes or eyes with slanting pupils as found in beasts of prey instantly make people feel uneasy. Something else that is immediately disconcerting is not to draw a pair of eyes, as seen in humans, but one, three or more.

▶ Play about with the number of arms and legs on your figure, or give your being tentacles, strange-looking skin or unusual ears, etc.

▶ Also give some thought to the inner values of your alien: do you want it to look malevolent, friendly, mysterious etc.? Draw up a list of characteristics and while making the first sketches, think about what you want to express in the shape and figure, and in the face of your alien. Do you want to create a feeling of fear, dread, alarm, amazement, liking?

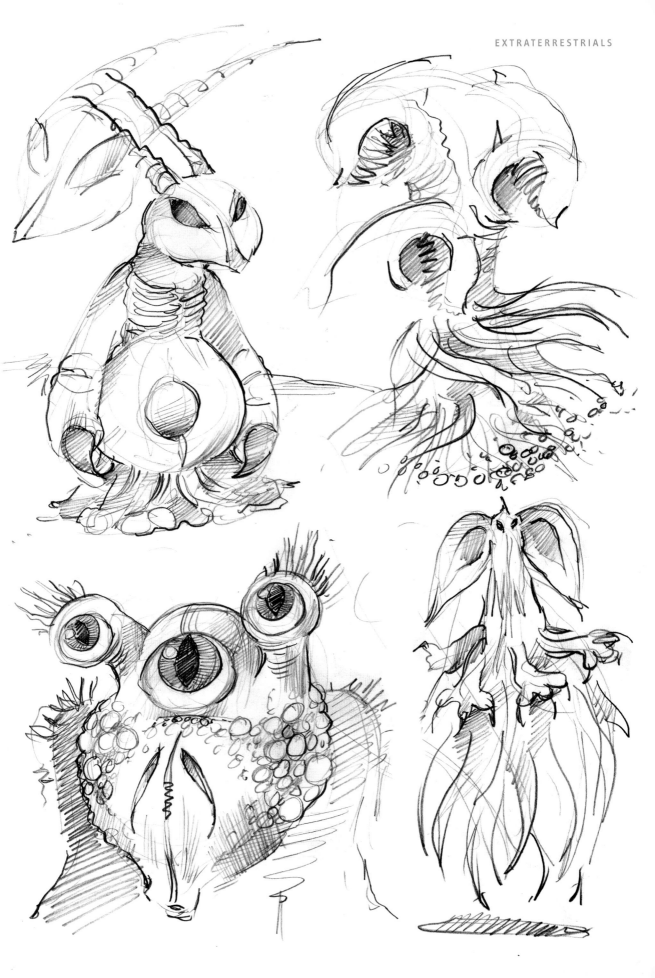

ALIEN SENTRY

Anyone who has a sentry such as this one guarding their precious possessions can rest assured that human intruders will run away at the mere sight of the figure; it combines almost all the elements that make a creature terrifying and dangerous in our eyes.

LEVEL OF DIFFICULTY

TIME REQUIRED
Approx. 60 minutes

MATERIALS
◆ Pencils
◆ White paper

Special features of the motif

This motif is one of the easier ones in the book as it is shown directly from the front and is therefore not very demanding in terms of perspective.

INFO
FLORA AND FAUNA
Plants are not used to portray aliens as often as animals are. Combining elements from the plant world looks especially outlandish to us.

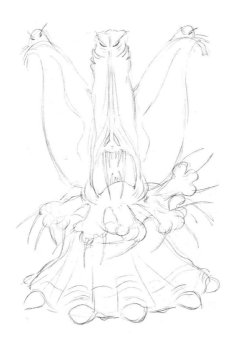

1 Draw a nice, clear outline and take a lot of care with the teeth and hands.

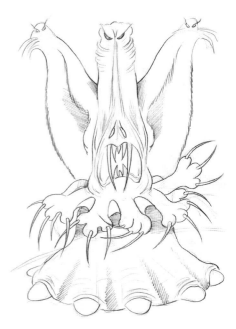

2 The figure has several striking features such as its slanting eyes, enormous ears, multiple arms and a foot that resembles a tree. Develop these characteristics in greater detail during the second stage.

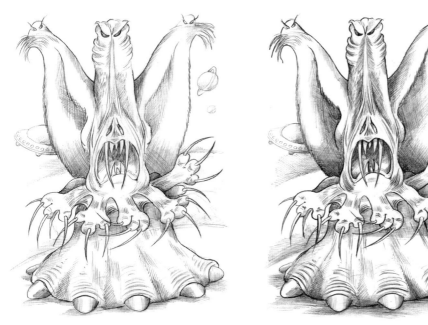

3 You can now continue with the shading you started in the second step. This will give a more three-dimensional look to your figure and develop the surface elements.

4 Develop the shading and elements of your creature still further.

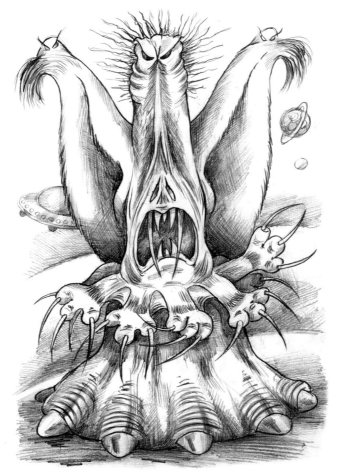

5 The freaky-looking hairs are added to the figure right at the end. You should only draw in as much of the background as is necessary – otherwise it will overload the drawing.

DETAIL

You can include a few planets or spaceships in the background to indicate that a being from another world is involved here.

27

ALIEN MAMA

The question of reproduction in extraterrestrials has been the subject of many a Science Fiction film, with this generally taking place in a most unappetising way. Despite being outlandish, the alien creature shown below still manages to provoke a certain affection even though it does not look as if it is to be trifled with.

How to succeed with this motif

You will best capture the ambivalence of this being if you manage to combine the fascination of the alien world with human warmth. It is important to make the posture of the mother look aggressive yet protective at the same time.

LEVEL OF DIFFICULTY

TIME REQUIRED

Approx. 90 minutes

MATERIALS

◆ Pencils
◆ White paper

INFO

FINDING MOTIFS

How does an extraterrestrial being have children? Or what might an Alien Mama look like? Either give the matter some thought or try to copy the figure shown here.

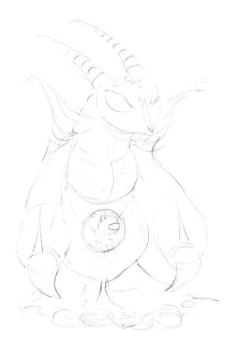

1 The first step is to outline all elements of the figure with simple strokes.

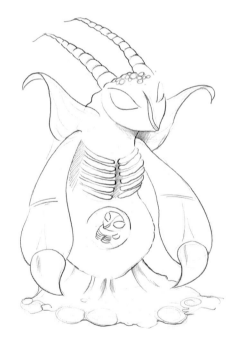

2 Now start to flesh out the basic design, developing the characteristics of the creature.

TIP

Take time to draw the ribs, feelers and the baby alien.

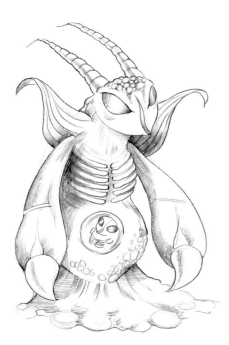

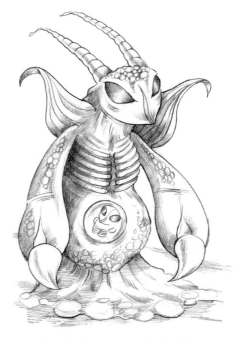

TIP

Whether this female creature awakens fear or sympathy in the beholder depends on how you yourself feel towards it. We unconsciously express our emotions in our drawings, and this affects the impression a figure will make.

3 Use fine shading to add the first areas of light and dark. Little circles and ovals create an uneven surface for the skin on the head and stomach.

4 Develop these elements further. Take care to draw the face and the little baby of the extraterrestrial being in loving detail. The rough texture of the skin is also emphasised by adding little circles on the arms.

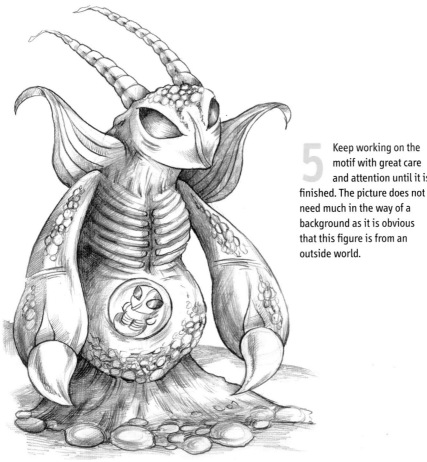

VARIATION

Brown coloured pencils have been used here, as this gives a softer look to the motif.

5 Keep working on the motif with great care and attention until it is finished. The picture does not need much in the way of a background as it is obvious that this figure is from an outside world.

THREE-HEADED ALIEN

How far does your imagination take you when thinking up new alien creatures? What sinister beings might lurk beyond our solar system? If you cannot come up with any ideas of your own, just copy the basic outline of this motif. It is very typical of beings from Science Fiction, which hones in on man's primeval fears.

Special features of the motif

It is not likely that anyone will fancy coming across this creature! It has sharp teeth like a piranha, sinuous tentacles and a single eye that fixes the beholder in a steely glare.

LEVEL OF DIFFICULTY

TIME REQUIRED
Approx. 90 minutes

MATERIALS
◆ Pencils
◆ White paper

INFO
INSPIRATION FROM NATURE
Look for photos of octopuses, squid or, even better, anemones, to understand how the many tentacles of the figure are created.

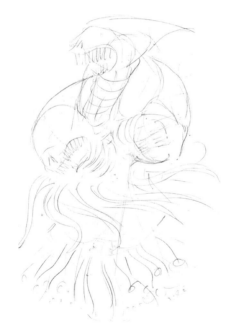

1 The main characteristics of this figure are its long pointed teeth and the cable-like connections attaching it to a sort of base plate. Draw them in carefully in your basic outline.

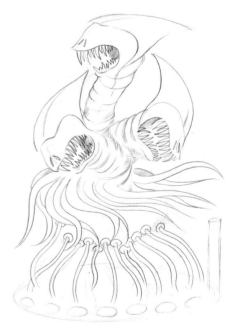

2 Now develop these characteristics further, so that they are clearly apparent.

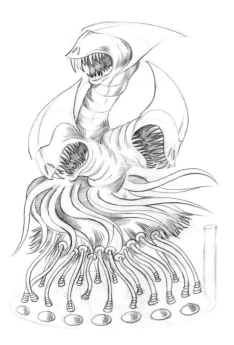

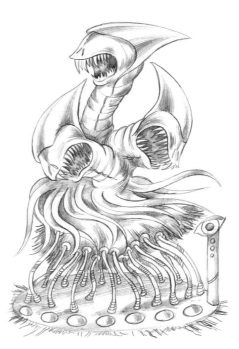

3 Now develop the details of the drawing by adding the first areas of shading.

4 Science Fiction thrives on unusual and bizarre ideas. As the creature's three heads are without eyes, one is simply drawn in on a separate pillar attached to the base plate.

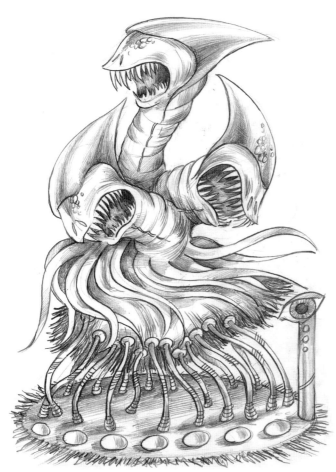

5 It is up to you to decide how many details you want to include. However, the important thing here is to make sure that the three connected heads have a strong facial expression.

INFO
AWAKENING PRIMEVAL FEARS

As if the darkness has come alive – this is why we are instantly affected by the sight of certain creatures if they remind us of wolves, sharks and other beasts of prey, creatures we faced many years ago when we were rather defenceless beings. Features such as teeth and claws are immediately understood all over the world.

TIP

To ensure sharp teeth look more effective, it is a good idea to make the inside of the mouth very dark.

DETAIL

You can make your creature look really voracious if you take the trouble to draw the mouth in great detail.

LIZARD ALIEN

In the world of Science Fiction aliens come in all shapes and sizes: beautiful maidens who turn into vile, slimy monsters, or the traditional idea of Martians in their UFOs. Science Fiction is, however, always looking for new beings, getting away from E.T. and Martians. At the cinema nowadays we come across aliens in every conceivable variation when it comes to appearance and character.

LEVEL OF DIFFICULTY

TIME REQUIRED

Approx. 90 minutes

MATERIALS

◆ Pencils
◆ White paper

Special features of the motif

Repeatedly thinking up new creatures and imagining how they have arrived on Earth from other planets is great fun. But fear can often also be mixed in with the fantasy, giving a fearsome look to a figure. This is the case with the lizard-like alien shown below.

INFO

FINDING INSPIRATION

This crawling, lizard-like alien also reminds us of a dragon. Such associations are a good way of encouraging a feeling of unease, as this exploits our fear of the sinister.

1 In terms of its basic structure, this creature resembles an iguana combined with the body of a scorpion. The tail, however, looks more like a caterpillar.

2 Once you have carefully outlined the figure with the right perspective, try to add detail to the individual elements.

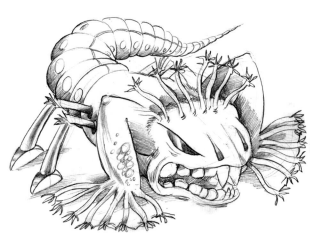

3 You can now start using shading to create the first areas of light and dark in your drawing. Add little tentacles to the ends of the stringy feet and to the fibres on the head.

4 Develop the body of the creature further using additional areas of shading and further structures.

TIP

Make the ground underneath the figure look darker with extra shading, so the lighter-coloured head stands out clearly.

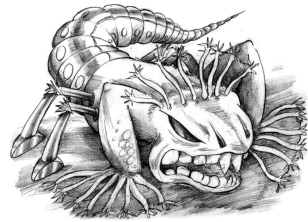

5 Keep working on your drawing carefully until it is finished. You can add fine lines to the limbs or teeth to round off the impression of a dangerous, crawling creature from outer space or the middle of the Earth.

TIP

With this alien it is impossible to tell at first glance whether the rings on its shell are made of natural or artificial material. Make use of such elements if you want the viewer to be unable to look away until he has solved the problem.

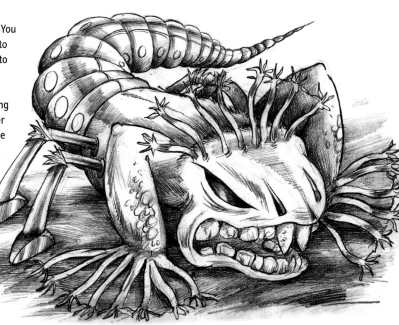

STRANGE BEINGS

There is already plenty of information on drawing extraterrestrial beings on pages 24 to 33. The page on the right now shows a number of other creatures from alien worlds. The figure shown bottom right can also be seen in colour on page 36.

Finding inspiration

When dealing with aliens, you may start noticing more and more creatures that fascinate you. This phenomenon forms part of the creative process as your subconscious is also working on finding a solution for the task you have set yourself. You should still consciously keep an eye out for life forms that might offer inspiration. Creatures from the bottom of the sea, the world of snails, slugs and worms, as well as close-up photography of mites can all act as a rich source of ideas.

Look inside yourself

You should also take a look at your own emotions: consider what delights or frightens you in a figure (teeth, ugly appearance?). This is another good way of creating an alien that will be really effective.

WORKSHOP TIPS

- ► You do not have to draw the perfect figure at the first attempt. Take your time and sketch several pages of drawings.

- ► You can make sketches at any time and virtually anywhere. The Old Masters always took a sketchpad with them on their travels. People today reach for their digital camera or the camera on their mobile, but these can also be used to capture impressions that will make your task easier later on.

- ► Sketches do not always look absolutely perfect, but you will see that they have their own charm, as your true creativity becomes most apparent in a sketch.

- ► Once you have made a few drafts, you can select the best sketches and use them to develop a proper drawing.

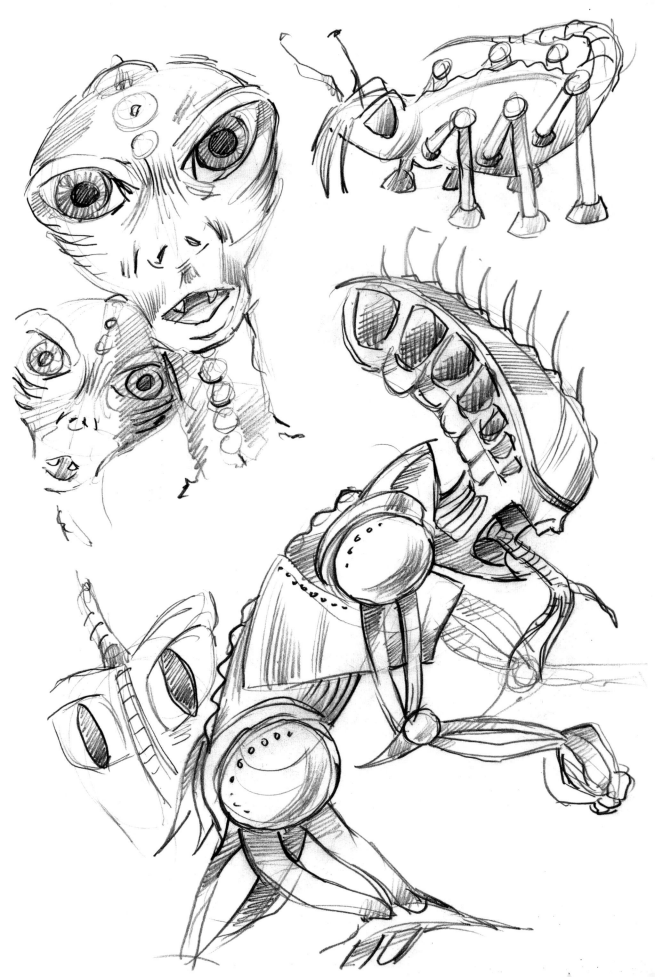

CYBORG ALIEN

Science Fiction does not only deal with beings that are half man, half machine but also half machine, half alien. These creatures are probably the most unpleasant-looking of all and are given a wide variety of attributes to make them seem dangerous. Sharp claws, spikes or a tongue that could be used to wipe out an opponent — these are just three of the many alternatives.

Special features of the motif

Hybrid beings which are half man and half machine now no longer seem so improbable to us, partly because of the various films showing this type of creature and partly due to the development of fascinating prosthetic limbs. Hybrids that are half machine, half alien, on the other hand, still seem quite fantastic: no-one has actually seen an extraterrestrial being yet. Or have they...?

LEVEL OF DIFFICULTY

TIME REQUIRED

Approx. 120 minutes

MATERIALS

- White, purple, blue and green coloured pencils
- Lilac-coloured paper

INFO
HOW TO SUCCEED WITH THIS MOTIF

This classical Sci-Fi motif calls for some skill in drawing. The aim here is to combine the mechanical-looking elements of the figure with its living parts to best effect, while making systematic use of colour.

1 Start by carefully building up the outline, making sure that you get the anatomy right.

2 Use a purple and a white coloured pencil to develop the design further, separating the individual elements of the drawing from each other. The first areas of purple shading are already added at this stage to give the figure a slightly more three-dimensional feel.

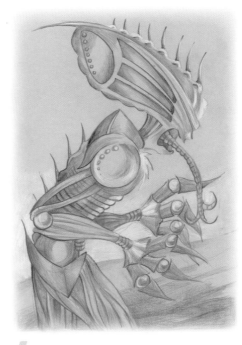

3 Continue developing your drawing. Add new details and structures to define the figure further.

4 Now use blue and green pencils for extra colour.

INFO

THE LANGUAGE OF COLOUR

Blue gives the surface a metallic gleam, while green emphasises the evil look of the figure.

5 These colours are also used to complete the drawing. The ground, as well as details on the figure, are given a few dark and light-coloured accents as a finishing touch. The picture is now complete.

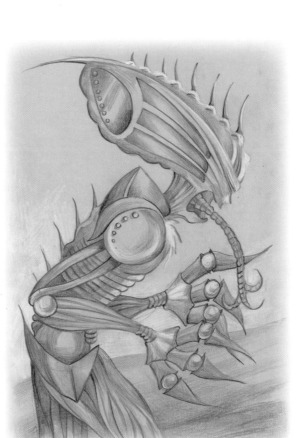

DETAIL

What is fascinating about this motif is its precision, which produces a subliminal feeling of fear. Draw in details such as the spikes on the head and back as shown here, applying a subtle sense of colour as well as a degree of precision that is almost draughtsman-like.

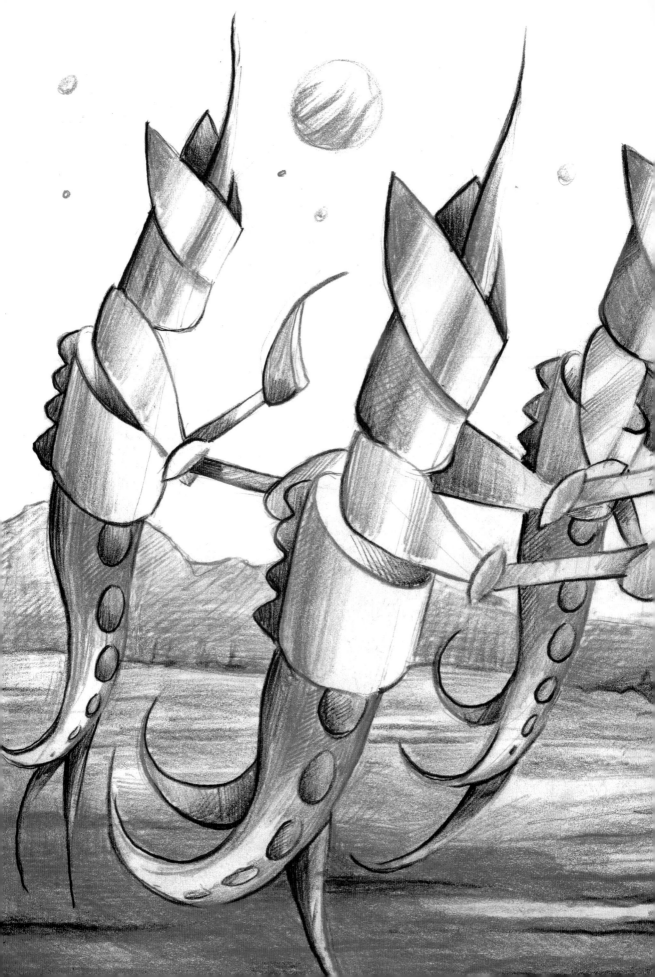

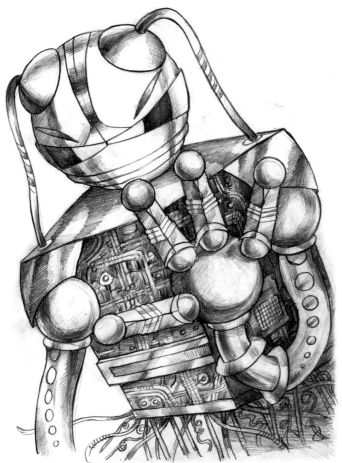

TIP

Our concept of robots generally comes from European or Anglo-American films, although in the Middle Ages people also thought up statues, dolls and mechanical warriors that could speak. If you are interested in this fascinating world, you can find initial information about this topic on the Internet by entering appropriate search words.

ROBOTS

Robots are machines that can be programmed to perform certain tasks. They are very important in Science Fiction as they open up unlimited technical possibilities to man. In narratives they often depart from their existence as simple machines and develop something on the lines of a soul in order to awaken a feeling of emotional closeness between the reader/viewer and the figure of the robot. In futuristic nightmare scenarios robots have frequently developed their intelligence to such a degree that they have become superior to man and start to rule the Earth. The term 'cyborg', on the other hand, is used to refer to an organism that includes artificial, technical and biological features.

ROBOTS

The term 'robot' comes from the Czech. It was used by the great Czech writer Karel Čapek at the beginning of the twentieth century and became known through works of Science Fiction. It owes its origin to the Slavonic robota = work, enforced labour, and initially only referred to a robot that resembled a human being. But as it is an ideal word for describing our increasingly complicated range of machines, it was quickly adopted by many inventors.

No uniform idea

A wide range of machines are known as robots, and it is therefore not surprising that the idea of what a robot looks like varies from country to country. While some people consider the humanoid C3-PO from 'Star Wars' to be a typical robot, others tend to think of the automatic machines used on car assembly lines.

WORKSHOP TIPS

▷ Give your imagination free rein when developing your own robots. All kinds have already been thought up, from the humanoid machine to the speaking super-computer. And if your creature reminds you of Frankenstein's monster, this is no reason for alarm.

▷ Choose either a simple object or a machine to use for your basic form and then add other elements and characteristics to create your figure.

▷ Do not forget that it must always be possible to program a robot – this is one of the most important features for recognising a robot.

▷ You can also take inspiration from complex pipework systems. Think how your robot can move most easily; it will have great freedom of movement if you add a lot of joints.

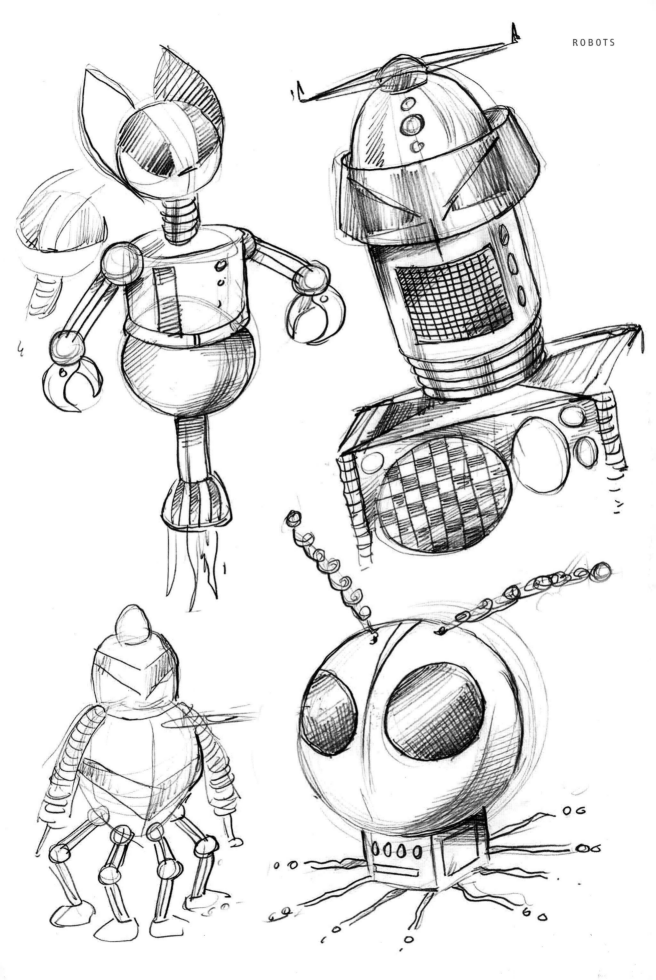

MARS ROBOTS

Nowadays moving robots have become a fixture in planet research programmes. In the world of Science Fiction they also act as helpers or pioneers on missions exploring hazardous new terrain.

LEVEL OF DIFFICULTY

TIME REQUIRED

Approx. 90 minutes

MATERIALS

- Pencils
- White paper

Special features of the motif

Apart from landing on the moon, man has never travelled to another planet. But in the world of Science Fiction everything is possible. In our case a robot has been dispatched to explore a new planet. Its basic structure is made up of very simple geometric shapes.

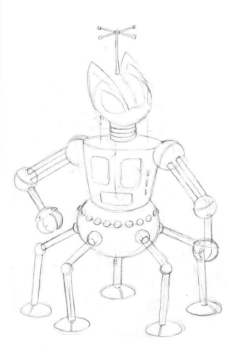

1 The basic forms are cones and balls.

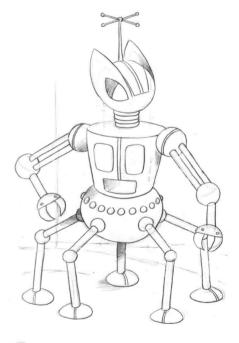

2 It is not as easy as you might think to draw these simple forms cleanly.

TIP

Take care even when just working on your rough draft and make sure you get the perspective right.

42

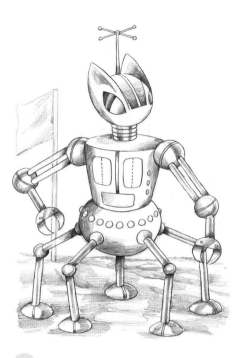

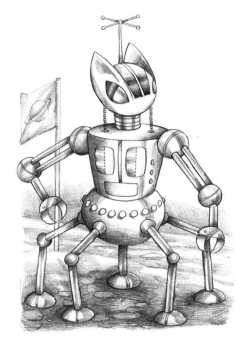

In the background roughly draw in the surface of the planet and a little flag; after all, the robot has to show that it has conquered it.

3 Initial areas of shading are used for the three-dimensional modelling of the individual parts of the robot.

4 Carefully develop the ground and the individual parts of the robot. Little circles and ovals can be used to produce the look of a stony surface on the ground.

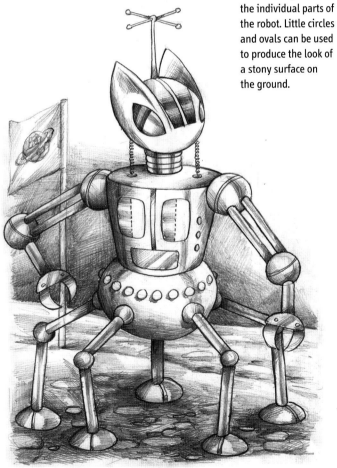

5 Finish by adding a dark area of shading behind the horizon, to create the impression of a dark sky.

DETAIL

The drawing can be rounded off nicely by placing a little planet on the flag.

ROBOT TORSO

Robots which develop a life of their own have already been the subject of numerous Science Fiction stories. Most people will be familiar with the 'Terminator' films in which machines seize control of the Earth, or the feeling robot with a soul, Number 5, from 'Short Circuit'.

LEVEL OF DIFFICULTY

TIME REQUIRED

Approx. 120 minutes

MATERIALS

◆ Pencils
◆ White paper

INFO

PATIENCE PLEASE

If this picture is to succeed, you must not become impatient, especially in the third and fourth steps. This drawing takes time.

Special features of the motif

This difficult motif is good practice if you have fairly advanced skills in drawing. Start creating the multilayer torso by first making a clear arrangement of fields with a few cable connections. The body is built up stage by stage like a complicated tattoo.

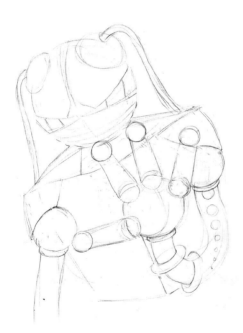

1 The perspective of the picture and the great detail in the robot's body call for some patience. This is why you should take good care when creating the geometric outline of the figure.

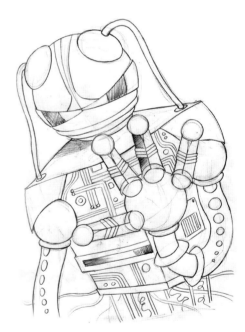

2 In the second step you can start adding some of the many details in the picture, such as the fine cables, switches, screws and buttons.

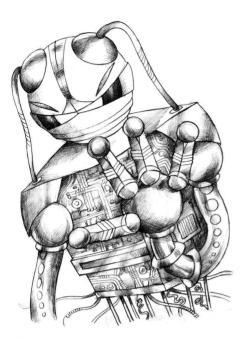

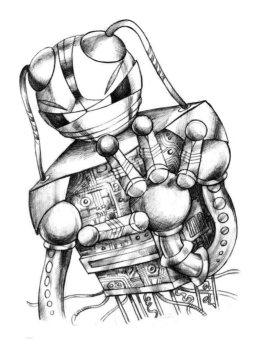

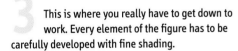

3 This is where you really have to get down to work. Every element of the figure has to be carefully developed with fine shading.

4 Continue working on the shading. Adding plenty of shading to the arms and hands will make these parts stand out from the rest of the body. This is important if you are to create a clear overall picture in spite of the extensive detailing.

5 Finish off by drawing in details on the tangle of cables under the robot's torso. Finally add a few dark accents with a soft pencil, and your picture is finished.

DETAIL

This piece of detailing clearly shows how numerous little elements have been included in the motif and how they have been linked in the drawing.

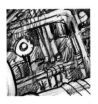

CYBORGS

This word comes from 'cybernetic organism'. In Science Fiction a cyborg is a hybrid being that is a combination of a living creature and a machine, with the organic and mechanical elements so intertwined that they are now inseparable. It is not possible to tell which was there first: man or machine. If a cyborg is to look convincing, it is important not to completely conceal all technical parts with the skin – leave some still visible. This makes it look as if these parts are growing in or out of the body. There are many examples of these creatures in the world of Science Fiction. Sometimes cyborgs are shown with sturdy mechanical parts, but you may occasionally notice delicate technical features with an elegant, feminised look to them.

Science Fiction cyborgs

If we look at modern medicine or biotechnology, these beings, which actually originate from the world of astronautics, have almost become a reality. Where does such a creature start being a cyborg and where does it stop? If we take a very narrow view of things, we could claim that someone with just glasses, a hearing aid or false teeth is basically a cyborg, or at least the next stage down. Nowadays this would apply to rather a lot of people!

INFO
VISIONS OF THE FUTURE
Modern medicine and technical developments lead us to suspect that one day the gap between man and machine will be closed.

WORKSHOP TIPS

▶ Marvellous technical achievements that make life easier for people with physical disabilities are a positive indicator that the future is already here. Let yourself be inspired by reading reports about scientific research.

▶ Do not forget that despite their many mechanical features, cyborgs are still supposed to be human. It is therefore important to make the biological elements of your figures look as lifelike as possible.

▶ One factor that makes for successful cyborgs is really to use your creativity when drawing the interfaces between the living and technical elements – but they should still look as plausible as possible.

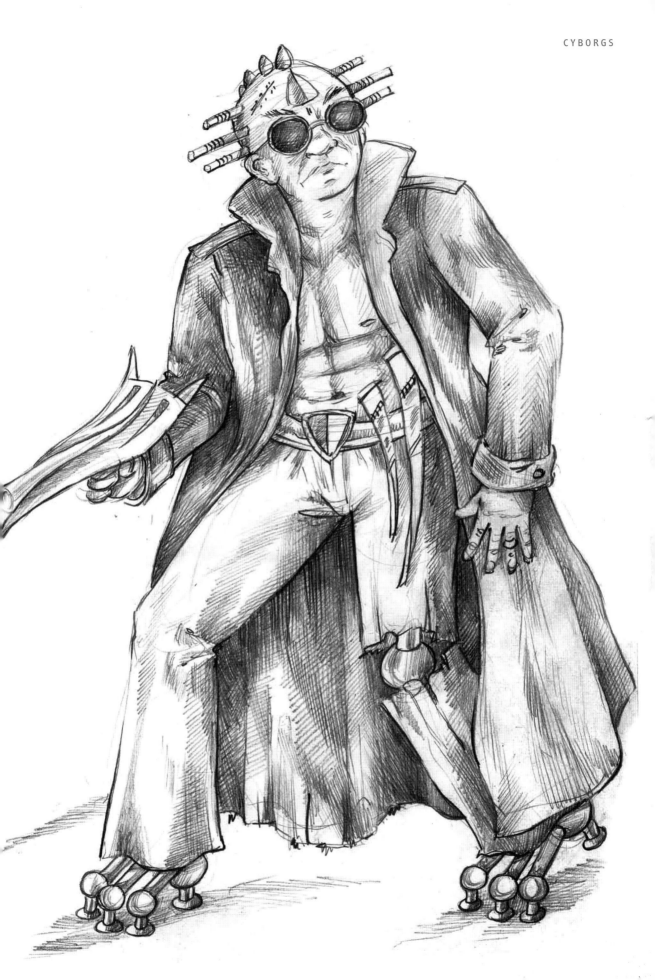

CYBORG TEENAGER

What an achievement it would be for humanity if, for example, the blind could be made to see again — whether using an unusual-looking contraption like the one shown below or something else thought up by yourself!

LEVEL OF DIFFICULTY

TIME REQUIRED

Approx. 90 minutes

MATERIALS

◆ Purple coloured pencil

◆ White paper

TIP

Try and put yourself into the figure's shoes: How might the boy be feeling wearing this contraption? Or is he not a human being at all, but a robot, with half of his face modelled on the human race?

Special features of the motif

This drawing calls for a certain amount of skill as it aims harmoniously to combine technical robot-like elements with human characteristics such as skin and hair.

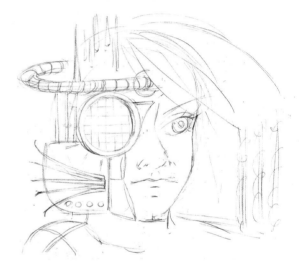

1 Careful structuring of the motif is essential from the outset, particularly when it comes to the technical parts.

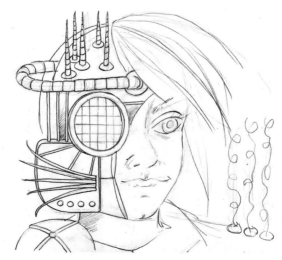

2 Once you have successfully completed the outline, the rest of the drawing will seem easier. Try to develop the individual details of the figure, giving free rein to your imagination.

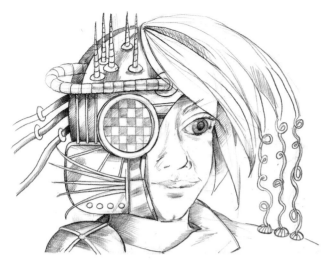

3 This is where the shading starts – and there is plenty of it! Every little detail calls for your full care and attention. Have a good think about what you want to make dark and what is to remain light.

INFO

STATE-OF-THE-ART TECHNOLOGY

Today there are already highly sensitive artificial limbs that can be controlled by brain impulses from their owners.

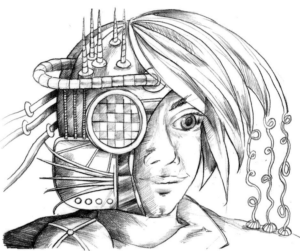

4 Try to give the face a very special expression.

VARIATION

A pencil was used to produce this variation, which has a more scientific look to it.

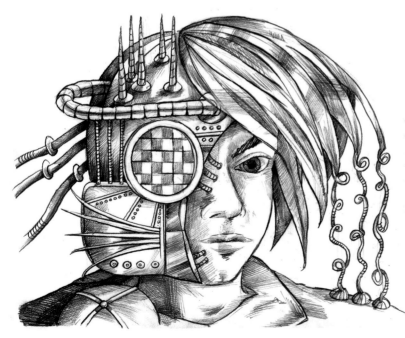

5 Carefully work on all the details until the very end. It is especially important to draw the hair well, as this takes up a good deal of the picture.

MUTANT CYBORG

Aesthetically, this motif reminds us of the 'Matrix' or 'Terminator' films – machines on a secret or menacing mission that have been almost perfectly disguised as humans. The ability of robots or aliens to turn themselves into creatures that look human is one of the basic primeval fears of man, as the threat they present is not apparent at first glance. Or are robots and aliens perhaps already among us?

LEVEL OF DIFFICULTY

TIME REQUIRED
Approx. 90 minutes

MATERIALS
◆ Pencils
◆ White paper

INFO
MACHINE PARTS

The protuberances on the head and the metal joints of this figure are clear indicators of its mechanical origin. With your own drawings think how you can incorporate other little signs of a cyborg in a 'person' that looks human.

How to succeed with this motif

It is not easy to capture the posture of this figure. If you are having problems with it, just copy the first step, blown up, on to a page of A4 and then go on from there.

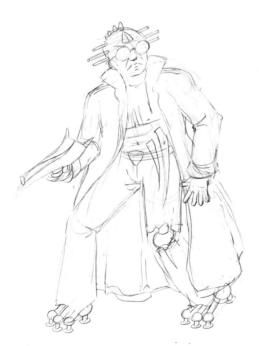

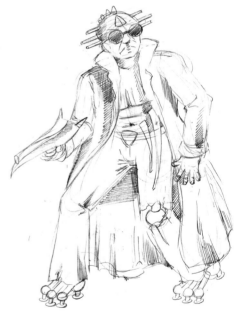

1 What seems at first sight to be human is more a machine with a human face. The feet, knee joints and parts of the head all point to its technical origin.

2 Just adding the first areas of shading to the long coat and the round glasses will make the figure look pretty lifelike. Carefully plan the little details on the hands and the weapons, including those on the belt.

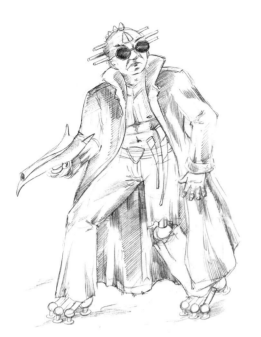

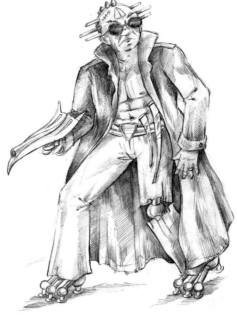

3 Continue with your drawing. Take a good look at how the folds in the coat fall so you can make them seem as natural as possible.

4 You have now progressed quite a long way with this motif. Carefully develop the contrast between the light-coloured trousers and the dark coat, as the alternation between light and dark is key to the impression created by this picture.

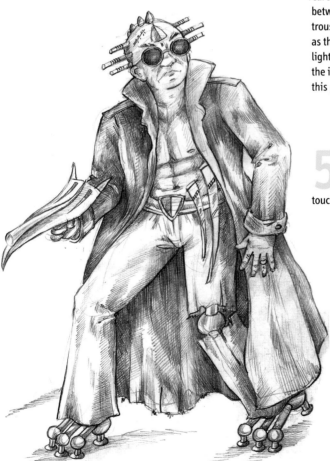

5 Put the finishing touches to the shading.

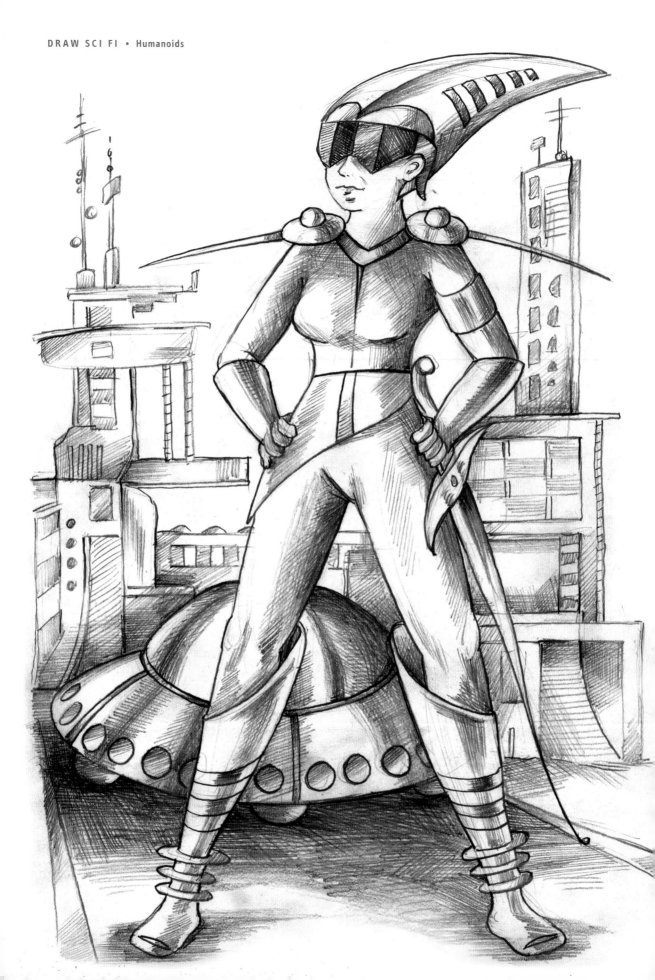

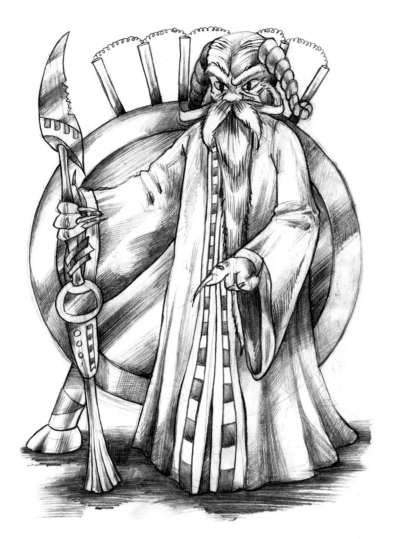

INFO
UTOPIAS

In a certain sense Science Fiction is also a search for a Utopia. This word was coined by the British author and statesman Sir Thomas More (1487–1535) in his novel of the same name, which deals with the search for an ideal world. This concept is also kept alive today by, for example, websites such as www.utopia.de.

HUMANOIDS

Virtually everyone has at some time wondered what the Earth and the human race could look like many years into the future, and whether man will even still exist by then.

When we learn about people from bygone ages, we notice enormous differences from modern man – in terms of height, weight or life expectancy, for example. And advances will continue to be made, not least thanks to changes in diet, daily habits and modern medicine.

No-one knows what humanity will look like in many years' time. We can only hope we will learn sufficiently from our mistakes, and the wars and hardships of the past, so that a modern man will indeed emerge.

TIP

If you are thinking about the man of tomorrow, you might find something to interest you in the past. In terms of appearance the hairstyles, clothing and art seen in the Ancient World, and earlier, back to prehistory, offer plenty of material for study. Works by such people as Plato and Aeschylus, as well as hymns and prayers from all cultures, can provide us with inspiration for a different concept of human beings.

HUMANOIDS

In terms of evolutionary history man did not develop until very late. It would undoubtedly be presumptuous to believe that we have now stopped developing and the man of today will remain the measure of all things for ever. It is interesting to look back at the past and draw conclusions about the future. Why were doors in ruined castles often so low or beds from olden days so short? It is perfectly simple: people were sometimes much smaller in those days. Study the evolution of man as if you were a proper researcher and arrive at your own conclusions here.

Where are we heading?

Climate change or terrorist attacks often lead us to paint a dismal picture of the future, but there are also far more positive visions to accompany the image of a new, modern man. Follow your instincts when creating your very own future world.

WORKSHOP TIPS

▶ Seek inspiration in the sketches of fashion designers. The idealised proportions and many futuristic-looking fashions are perfect when it comes to thinking up new ideas.

▶ Before you start drawing, write a list of what you personally would like to see or dream of in the future. Use this list as a basis for your pictures.

▶ Have a look at some statistics, for example the development of man in relation to life expectancy, height or medical/technical advances. Project these figures into the remote future so you get an idea of how things might look many years from now.

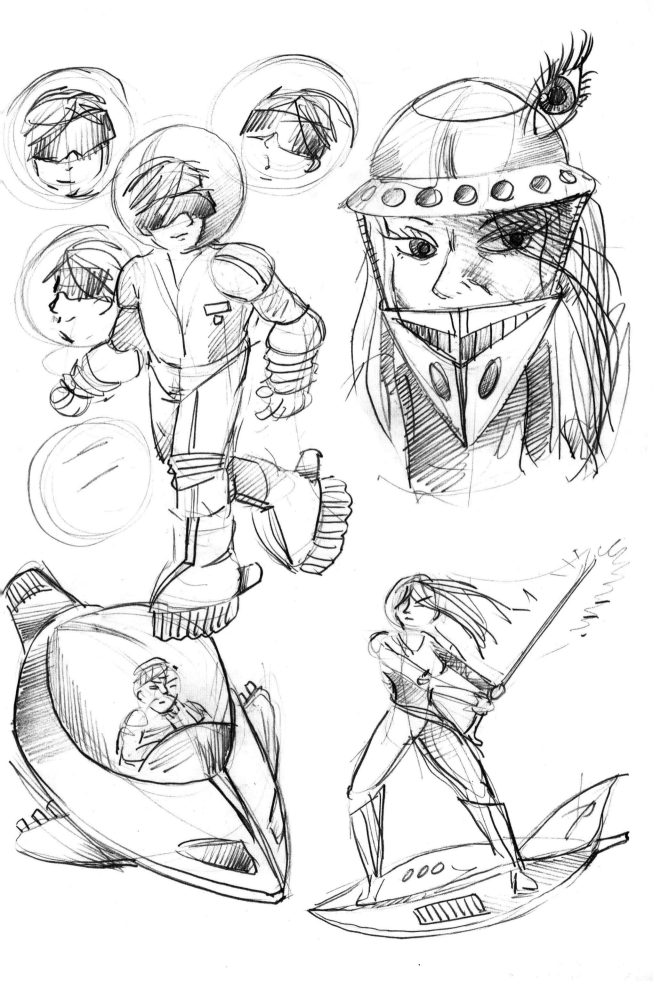

FUTURE WOMAN

The woman of tomorrow, her fashion style, environment and means of travel are the subject of this dynamic drawing.

LEVEL OF DIFFICULTY

TIME REQUIRED
Approx. 90 minutes

MATERIALS
◆ Pencils
◆ White paper

Special features of the motif

The woman shown here, who lives in a not-too-distant future, does not look gloomy and burdened with worry, but optimistic, determined and bursting with positive energy. She conjures up the image of a heroine, with her central position in the foreground of the drawing emphasising the feeling of strength radiating from this figure.

Further ideas about heroes and heroines can be found on pages 78–79.

INFO
HOW TO SUCCEED WITH THIS MOTIF

Make sure that you get the proportions of the woman's body right here, as well as creating a good perspective for the spaceship and buildings in the background.

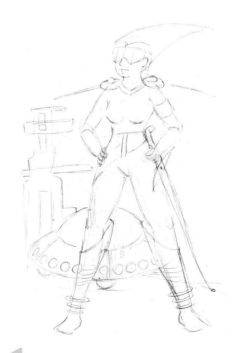

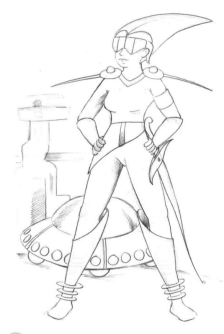

1 Try and capture all the positive aspects of this figure right from the start and incorporate this in the basic structure of your picture.

2 Use slightly heavier strokes and the initial areas of shading to develop your design.

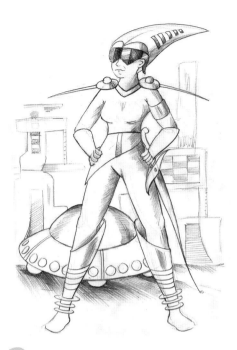

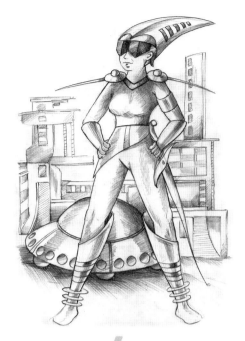

TIP

The lines used for the shading on the ground underneath the spaceship lead towards a possible vanishing point in terms of perspective. This gives us the feeling that the figure has zoomed into the foreground.

3 Add more shading to make the figure stand out from the background.

 Continue with your shading – also paying attention to the buildings in the background. Small windows, stairways and pillars can be used to heighten the impression of a futuristic façade.

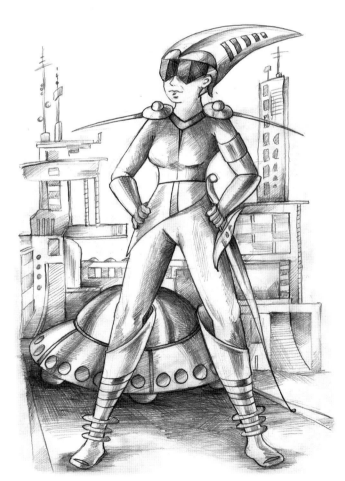

 Adding dark areas of shading to the road behind the woman's legs will help the figure stand out from the background.

TIP

The sides of the road, which lead towards the vanishing point, give the drawing the intended dynamics of perspective.

INFO
CLOTHING OF TOMORROW

Drab and functional or bright and simple – this is how many illustrators see the clothing of tomorrow. Since the cult series 'Space 1999' was screened on UK television in 1975, such garments have seemed to be made of easy-care artificial fibres.

SPACE TOURIST

I t is not that long since the media reported the amazing news about the first tourist in space. But there is still a very long way to go from an individual joining a space mission to the man (or woman) on the street jetting off with a rucksack into the universe on a package trip. Many, however, dream of flying into space and seeing the Earth from a distance.

LEVEL OF DIFFICULTY

TIME REQUIRED

Approx. 90 minutes

MATERIALS

- ◆ Pencils
- ◆ White paper

INFO

WHAT DOES THE EARTH COST?

It is not just the dream of anyone being able to take a trip into space that represents a bold vision of the future. Just give a thought to the costs involved. Science Fiction often shows man not only his technical but also his financial limits. Imagine all the things we might be able to achieve if only unlimited funding for research were available?

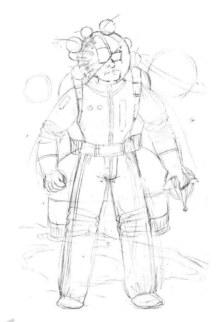

1 With the Space Tourist the normal astronaut has been taken a stage further. This is why we need to include a few special accessories, such as 'multi-view balls' on the helmet, allowing the figure to keep an eye out in all directions at once, or the hand-beam device. Make sure you include all these elements when drawing your outline.

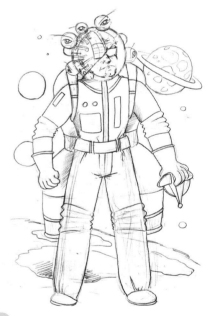

2 Now develop your initial sketch further. Do not forget about the background and the ground of the planet on which the figure is standing. Use fine shading to create the first areas of light and dark.

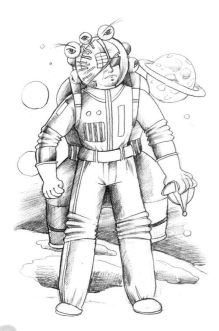

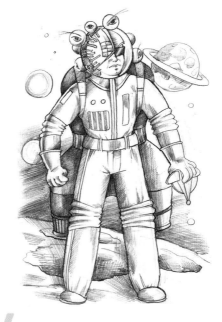

3 Add more shading to suggest the dark atmosphere of the universe and draw in the details on the Space Tourist's suit. Potholes in the ground and little craters on the planet also offer plenty of scope for creativity.

4 Large areas of shading can be used to make the rocket backpack and the sky stand out from the lighter-coloured space suit. When drawing the head, concentrate on adding in the fine details.

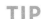

TIP

Science Fiction figures often come under criticism because their clothing, equipment and weapons are over the top. Make sure the items you include in your drawings are as simple as possible – we humans are basically very practical beings.

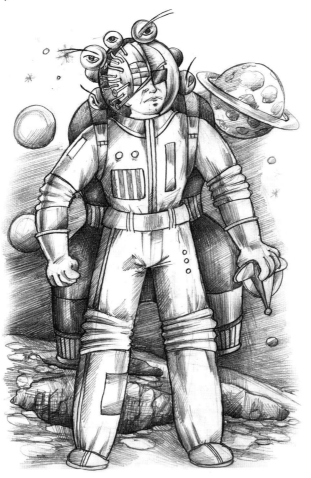

5 Finish off by developing the background and landscape around the figure. But do not take it too far – here less is often more.

DETAIL

Use little ovals to suggest stony ground or rubble.

GALAXY GIRL

Nowadays spectacles have become a popular fashion accessory, while a hearing aid — something that is also designed to make up for a physical disability — is still seen as being rather unattractive. In the future everything will be different: glasses, hearing aids or skin sensors will be combined into a multifunctional device that will offer us greatly heightened sensory perception, with our different senses being linked up.

LEVEL OF DIFFICULTY

TIME REQUIRED

Approx. 60 minutes

MATERIALS

◆ Pencils
◆ White paper

Special features of the motif

The picture shows a young, serious-looking girl with a smooth, unblemished complexion. This is in stark contrast to the elaborate construction that resembles a pair of glasses linking the eyes, ears and skin.

1 This futuristic portrait of a teenager revolves around her hair and the unusual eyewear she is sporting.

TIP

When making your first sketch, try hard to get the hair and 'glasses' right as well as the arrangement of the eyes, nose and mouth.

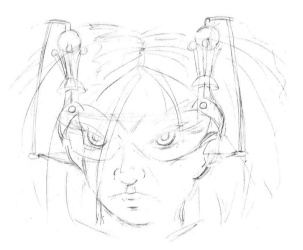

INFO

STANDARD ISSUE

Contraptions such as the one shown above might become standard issue for everyone in the not too distant future — such devices would then be available in all fashion styles. So let your imagination run wild here!

2 Use large areas of shading and strong, precise lines to develop the motif further.

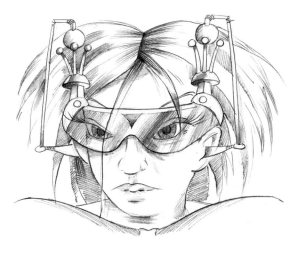

3 Continue with the shading. For the hair it is sufficient to draw in a few sections to achieve a three-dimensional effect in the picture. The different geometric elements of the glasses are developed further with some fine shading.

4 Creating the hair calls for a bit of patience as each strand has to be drawn in carefully.

TIP

When doing so, make sure that you clearly separate the hair from the technical elements.

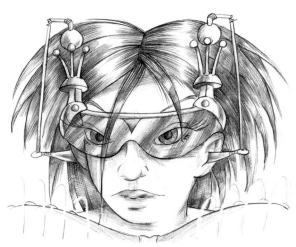

DETAIL

One special problem is capturing the transparent look of the lenses in the glasses. You can achieve this by drawing the diagonal lines of the shading partly over the eyes.

5 At the end add a few dark accents with a softer pencil. On the shoulders fine wires with mini-sensors are added as the final detail. The portrait of a girl from the future is now finished!

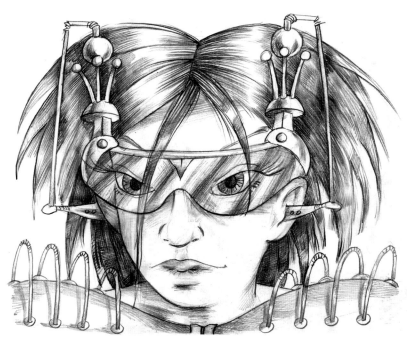

61

INDIAN SPACE SURFER

The range of ideas found in the world of Science Fiction is virtually unlimited. While some visions seem plausible in a distant future, there are others which will probably never come about.

LEVEL OF DIFFICULTY

TIME REQUIRED

Approx. 60 minutes

MATERIALS

◆ Pencils
◆ White paper

INFO

A VISION OF THE FUTURE?

How 'real' does Science Fiction have to be? There is no right or wrong answer to this question. We naturally assume the future will include technical advances, but nobody knows what will really happen. So do not allow anyone else to 'spoil' your personal view of the future.

Special features of the motif

Going beyond all the technical constraints, Science Fiction is also looking for the lifestyle of tomorrow – and the remote future. Undoubtedly one of the finest dreams is to float through time and space as freely as this young girl.

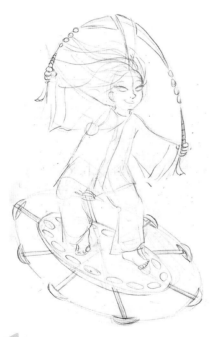

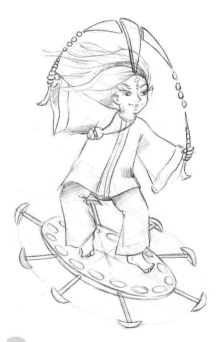

1 To make the dream of surfing space a reality in your drawing, you first have to create a good structure for it. Try to copy the outlines shown in step 1 as accurately as possible.

2 Develop the basic design carefully, giving special attention to making the eyes and hair look attractive.

TIP

The girl's face is also very important for this motif and should be drawn with as much care as her hair floating in the breeze.

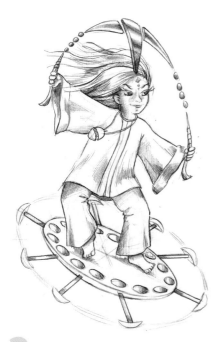

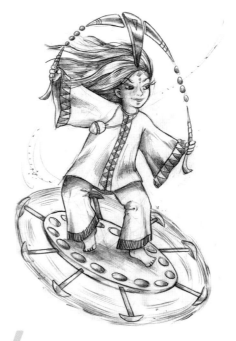

TIP

If you want to make the girl's thick mane of hair look as effective as possible, you must draw in the individual braids waving in the breeze with great care and attention.

3 Use plenty of fine shading to give a more three-dimensional look to the girl and the round surfboard. Drawing the hair is especially enjoyable here.

4 The motif acquires an Indian look to it through the fine patterns on the girl's clothes and the mysterious decoration of her face.

DETAIL

The combination of the latest technology and ancient cultural traditions such as those of India is always especially fascinating. Elements of Maori culture, African tribes or the Inuit people are also a great source of inspiration.

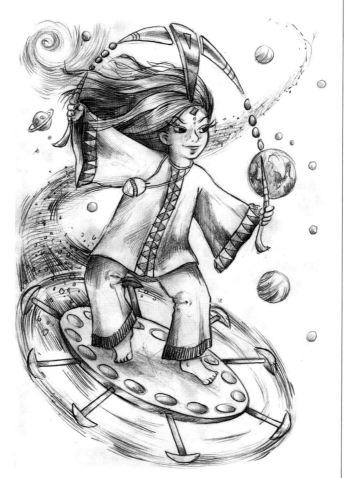

5 As this picture shows a Space Surfer, it is important to finish it off at the end by drawing in the universe with its planets and heavenly bodies, as well as the path traced by the board.

TIP

Make the surfboard look as if it is moving by adding little lines at the outside edges to suggest motion.

TIMEGATE

People with visions of the future are probably fascinated most by the idea of time travel or of discovering another world. Numerous books and films have already dealt with this subject and whetted our appetite for it. The only question here is whether it would really be desirable for man to be able to change the course of events, either in advance or in retrospect. The result would probably be absolute chaos.

LEVEL OF DIFFICULTY

TIME REQUIRED
Approx. 90 minutes

MATERIALS
- Pencils
- White paper

INFO
DRAWING THE FUTURE IN LOVING DETAIL
This motif offers plenty of opportunity for attractive detailing such as on the edges of the robe. You can, however, also choose different clothing for your figure, drawing a richly decorated cloak over a tunic-like garment.

Special features of the motif

This motif is particularly interesting due to the combination of a futuristic creature resembling a human being with some kind of technical implement.

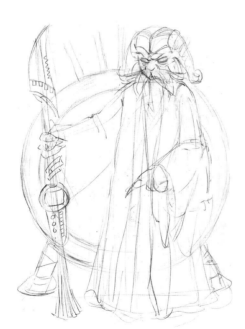

1 You should have basic skills in drawing figures and technical objects if you are to master this motif from the start.

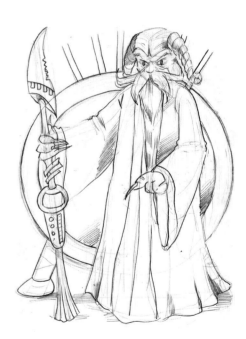

2 Once you have got the basic outlines right, adding a few broad areas of shading and more precise lines will help you progress with this drawing.

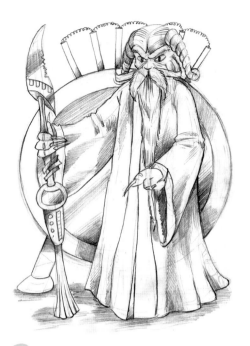

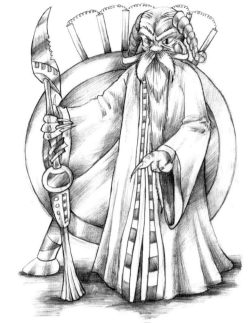

3 Continue with the shading so that the basic form of the drawing is almost complete.

4 Add a fine pattern to the robes of the figure, for example at the edges. Such decoration will make the garment look more elegant. Draw in extra details on the mysterious staff.

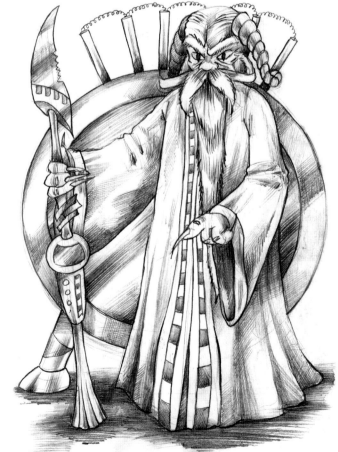

5 Finish off the drawing by adding dark accents with a soft pencil. Here, for example, the ground underneath the figure has been made darker for greater emphasis, and the gleam on the Timegate has also been heightened slightly.

DETAIL

You should take a lot of care when drawing the face on a creature that might be a human being from the future – or possibly a different species altogether.

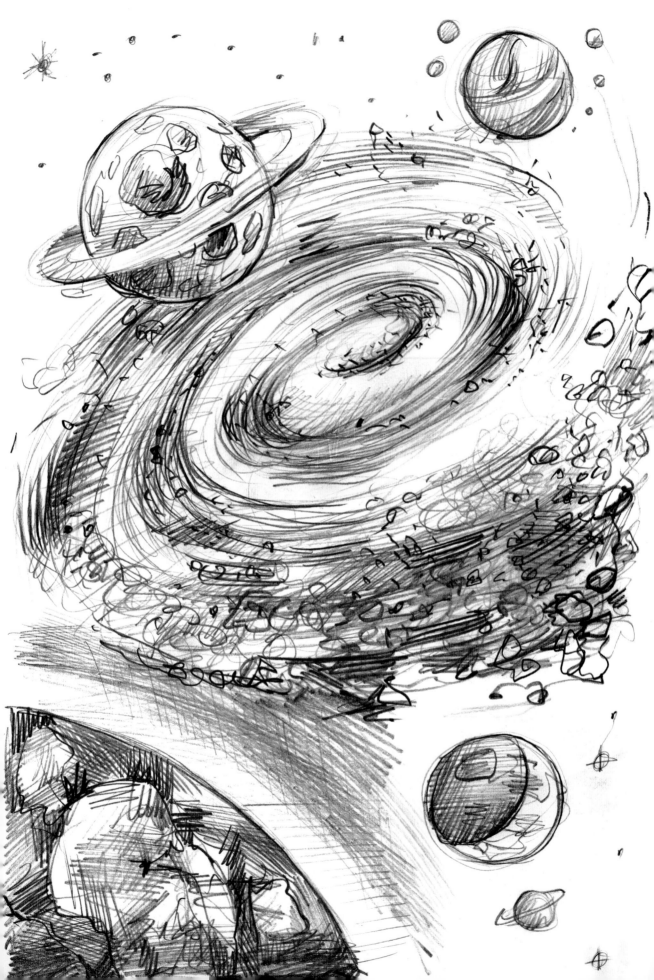

The greatest challenge facing Science Fiction illustrators is, of course, to develop their own visions of the future, which not only include human and extraterrestrial figures but also clothing and fashion, vehicles, spaceships, etc. Creating your own world is not just exciting – it is also great fun seeing how you can build up, stroke by stroke, figures and scenarios that have never been seen before. You have real creative freedom here and can give free rein to your imagination.

At the same time you should also incorporate your experience of life, as well as your ideas as to how the human race will develop in terms of technology and morality.

LEARNING OBJECTIVES

▶ If you ask the right questions and are open-minded about the answers, you will come up with amazing solutions that will prove rewarding for any illustrator. And the most thrilling thing is that you can see whether your visions are shared by other people. Who knows, perhaps high-tech companies or large design studios are already working on similar ideas?

▶ No-one is born a master. This is why you simply have to work hard to make progress with drawing. It is a good idea to scale down your expectations slightly and first try to approach your chosen subject with sketches.

▶ Do not think too hard when you are practising. For example, if, when you are doodling, you start wondering exactly where the technical side comes in, you will block your creative impulses. Just let yourself be guided by your instincts.

▶ Although many motifs are most effective when drawn with the clean lines of the lead pencil, Science Fiction also invites you to try out colour.

CITIES OF TOMORROW

What will man's immediate environment look like in the future? Here it is interesting to draw not only the wider context of the galaxies, but also the specific environments that the beings of tomorrow will inhabit.

INFO

ATMOSPHERE

In the world of Science Fiction, more than in most other genres, a key role is played by the interaction between individual figures, means of transport and the backdrop. All this gives an entire scene its coherence. It is only with all of the above that we can create the convincing Sci-Fi atmosphere we know from many Science Fiction films.

A vision is born

The drawing shows several visions of how a city of the future might well look. Buildings resembling space ships alternate with enormous outlandish structures housing thousands of human beings, robots and cyborgs – and possibly also visitors from other planets. Man – and possibly also selected plants and animals – might need to live in such protected 'compounds' if our planet one day becomes more hostile.

▸ Ask yourself the following questions: What might a city of tomorrow look like? What characterises a modern building? Perhaps there will no longer be houses as we know them today, just mobile dwellings equipped with numerous functions – almost like an organism that lives in symbiosis with man.

▸ Allow yourself to be inspired by the drawing and think about other solutions. What looks very urban here may seem very different close up in nature. Will there be houses which have been adapted to nature and make use of natural resources as a source of energy? Just pick up your pencil and become an architect of the future!

▸ The great thing here is that you do not have to submit to the actual constraints of society, but can design your drawings just how you want them.

WORKSHOP TIPS

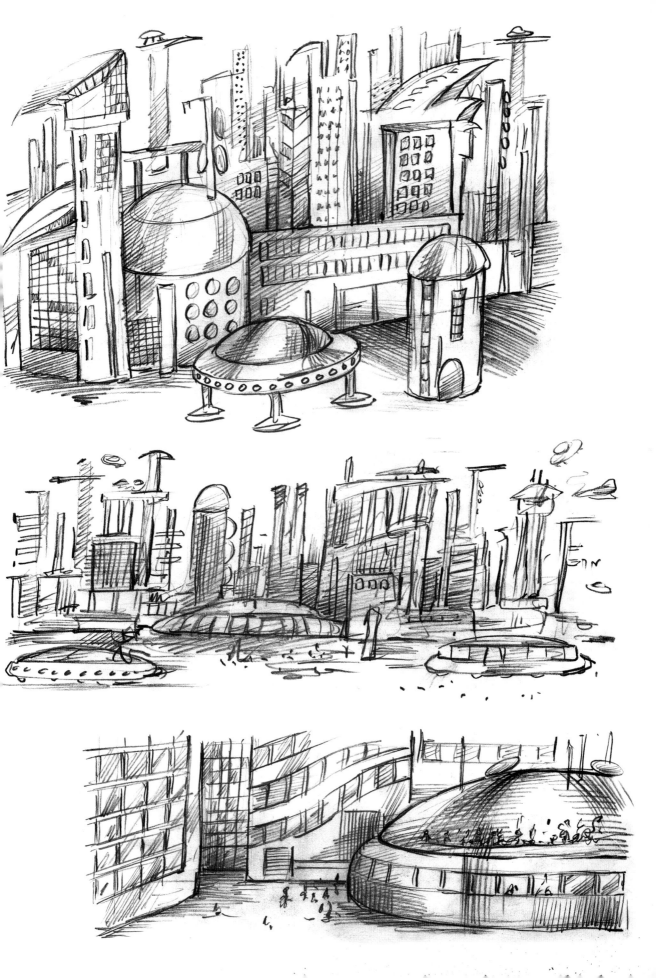

TECHNOLOGY OF THE FUTURE

It's something no Science Fiction illustrator can avoid: Sci-Fi drawings always include technical details in combination with living elements. That is, they incorporate technology.

INFO

RESEARCH INTO THE FUTURE

When entered on the Internet, the above search term also offers interesting insights into current scientific research into the specific form our future might take.

Creative technology

Page 71 shows several little drawings, each with a technical background to them. The basic repertoire of a Sci-Fi illustrator includes objects resembling computer circuitry, smooth metal casings or little screws. However, something that tends to sound rather boring can actually be fun in a creative environment.
When drawing, shake off all the real-life constraints of technology. It is up to you to decide what works and what doesn't.

Keeping your eyes open

When you are looking for suitable subjects for your technical motifs or details, you will find plenty of inspiration in the environment around you. As seen on pages 46–47 and 72–73, vehicles, weapons and artificial limbs can be an interesting source of material. But little items like telephones, mobiles, remote control devices, PCs, writing implements or keys will also change in design. How might doors and lifts function – and what about lamps or washing machines?

You can also take a systematic approach here and seek inspiration in:
▹ little appliances such as hairdryers, kettles, etc.
▹ entertainment and the media
▹ energy supply.

You can also incorporate your own special skills or hobbies, for example drawing the printer of tomorrow or a futuristic locomotive, a completely re-invented bicycle etc.

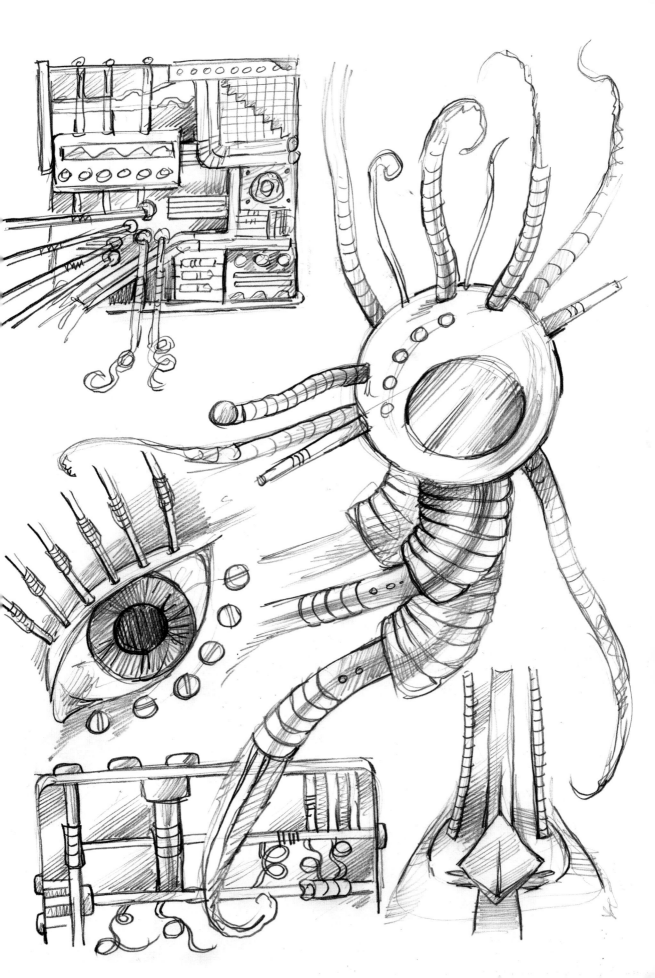

MOBILITY

The future will undoubtedly also be dominated by the question of mobility. Until someone invents truly alternative means of transport, such as teleportation or beaming, we will all have to content ourselves with conventional methods, whether we like it or not.

Vehicles

The future is bound to include unbelievable achievements here as well. Travelling at the speed of light or in the ocean deeps will become a matter of course. But what will the vehicles of tomorrow look like? The sketch offers a few ideas. These drawings are characterised by streamlined forms, shapes resembling animals and simple functional design.

TIP

But perhaps things will look totally different to this. Have a think just what you want the car, boat or plane to achieve in the future and illustrate this in your drawings.

INFO
POSSIBLE MODES OF TRANSPORT

Teleportation means travel through the force of our own thoughts, and beaming means moving from place to place using a suitable machine (beamer), without a mobile means of transport such as cars.

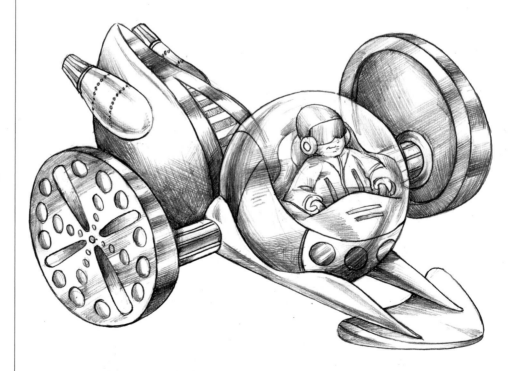

72

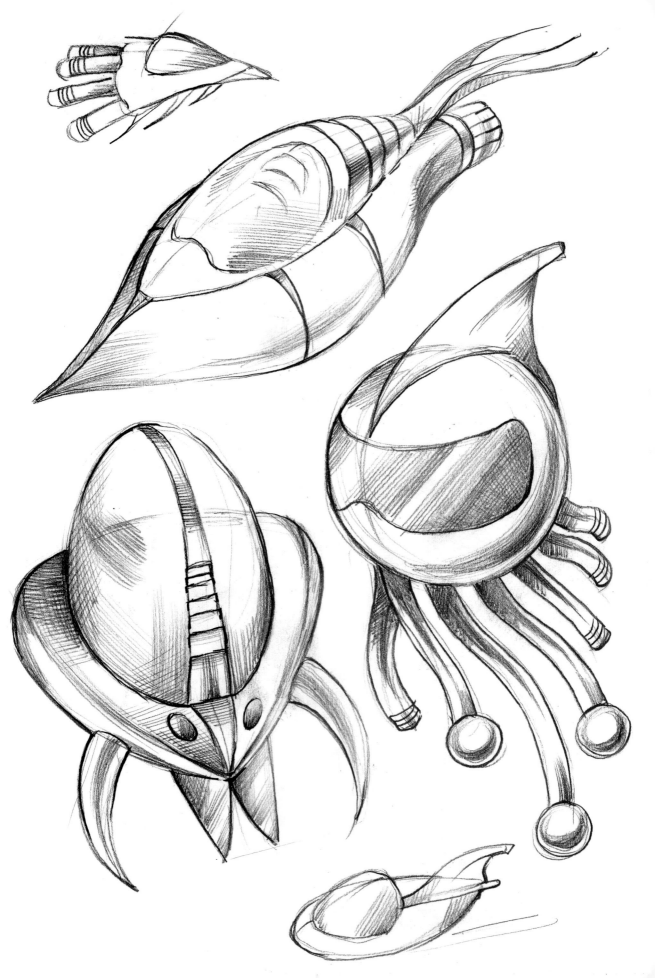

You have learned about the different aspects of drawing Science Fiction and can now proceed to create a complete scene. You can only create the right Sci-Fi atmosphere if you combine alien beings with spaceships and planet landscapes. If you run into difficulties here, take your own sketches of figures, spaceships or planets, copy them (possibly reducing them in size) and put them together to form a collage. This is a very simple way of assembling a Sci-Fi scene.

Variety is the name of the game

This, however, means that the Sci-Fi illustrator has to cope with very different subjects such as landscapes, portraits or fantastic worlds. There are many good drawing books that offer you good material for further study over a wide range of topics. But everyone has to find their own way of approaching this theme.

▷ When developing such a complex motif as an alien world, it is a good idea to use sketches, as it takes some skill to compose the individual elements of a picture and arrange them on the page.

▷ If you work in miniature format or sketch size, this will make you concentrate on the essentials, something that is very helpful if your design is to be clear and convincing.

▷ A little sketch will be very useful when you go on to draw a large picture. Sometimes it is even a good idea to simply copy the sketch, increasing it in size.

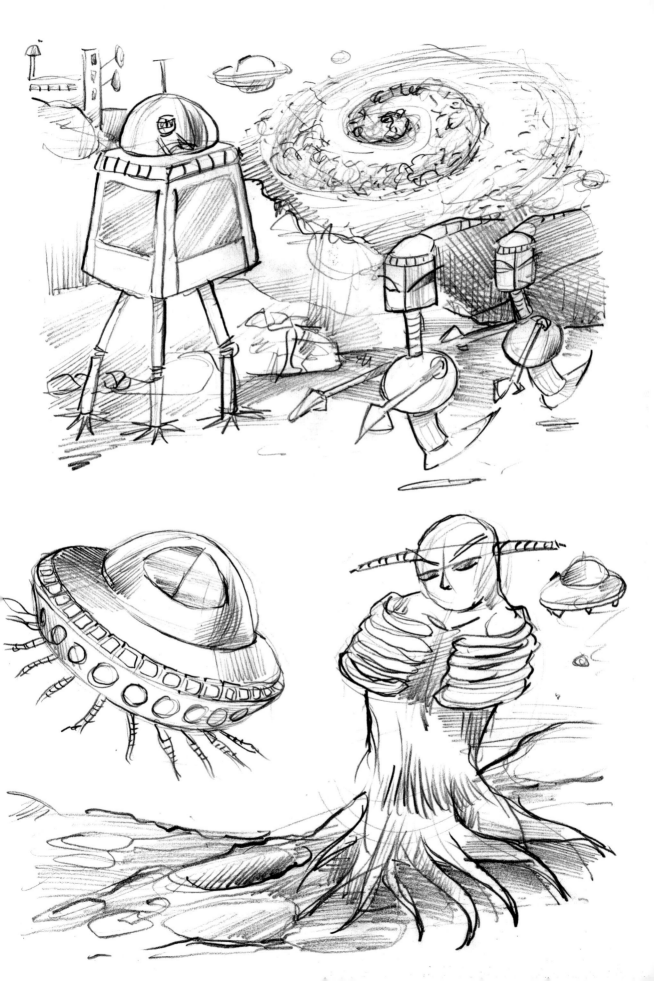

YOUR PERSONAL MASTERPIECE

Once you have created a few of your own drawings while working through this book, you can then go on to something more difficult: your personal masterpiece.

A challenge

Once you have drawn several different figures and are feeling confident enough, you could try your hand at an entire landscape.

1 This motif is a typical example of a world which might exist on an alien planet. Carefully examine how the individual elements of the picture have been created in the first step.

2 Use a blue coloured pencil to work over the drawing and separate the numerous elements of the picture from each other.

TIP
Always first plan the overall outline before going into further detail.

3 A purple pencil will help you give the individual figures and elements a more three-dimensional look, reinforcing the structure of your picture.

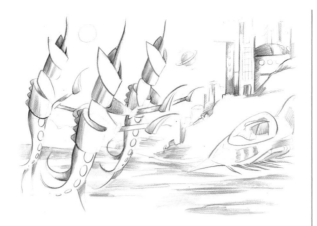

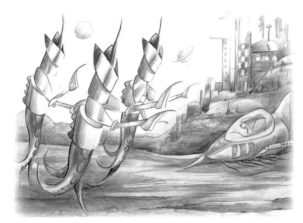

4 Large areas of shading can be used to bring together the individual elements of your picture for a more coherent look.

TIP

Draw in plenty of little details on the buildings and mountains in the background, and also create a special structure for the ground underneath the robots.

5 Finish off your picture using a dark blue pencil to add a few dark accents.

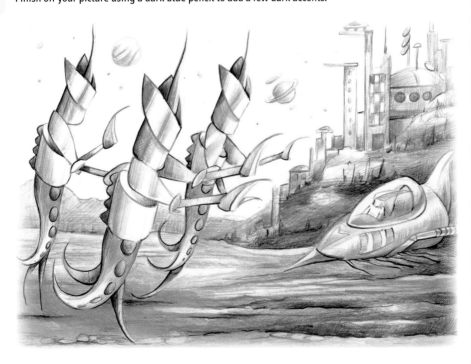

WORKSHOP

VARIATION

You can give this scene a special atmosphere by using yellow, orange and red — conjuring up life on Mars in a remote future.

SCIENCE FICTION HEROES

Whether you want to draw a hero or heroine from any other story or heroes from the world of Science Fiction, there are a few things you should bear in mind when starting your first sketches and doodles.

Essential to the story

Heroes and heroines are figures who bring together all the events of a narrative. They embody the quality of the action; they are good or bad or turn into something else in the course of the story. Heroes and heroines have affected our thoughts, feelings and hopes since the start of the human race: from Adam and Eve, through King Lear to Spiderman and Lara Croft – there is no era that has not had its own figures as heroes.

▶ If you want to draw a Science Fiction hero, make sure you give him a free, upright posture that does not look challenging. The head should be raised and the eyes directed forwards. The gestures of this figure – including those when he is in motion – should be open and honest. Heroes instinctively rely on themselves and good fortune. Try to capture this in the basic characteristics of your figures.

▶ In some ways there is no genre better suited to depict heroes and heroines than Science Fiction. You can set off the character and personality of your figures by using fantastic garments with an opulent, romantic style to them or you can concentrate on essentials by opting for the simplicity of a plain, close-fitting costume.

▶ The heroes of tomorrow also offer great scope for design in terms of suitable accessories: futuristic weapons, mysterious amulets and unusual-looking headgear can all be used to round off the impression made by your figures, whether male or female.

WORKSHOP TIPS

First published in Great Britain 2009 by
Search Press Limited, Wellwood, North Farm Road,
Tunbridge Wells, Kent TN2 3DR

Original German edition published as Werkstatt
Zeichnen – Science Fiction

Copyright © 2008 frechverlag GmbH, Stuttgart,
Germany (www.frech.de)

This edition published by arrangement with Claudia
Böhme Rights & Literary Agency, Hanover, Germany
(www.agency-boehme.com)

English translation by Cicero Translations

English edition edited and typeset by
GreenGate Publishing Services, Tonbridge, Kent

ISBN: 978-1-84448-477-5

PROJECT DIRECTOR: Dr. Christiane Voigt
PROJECT MANAGER AND EDITOR:
Verena Zemme
LAYOUT: Petra Theilfarth

Printed in Malaysia.